IMAGES
of America

HARPERS FERRY

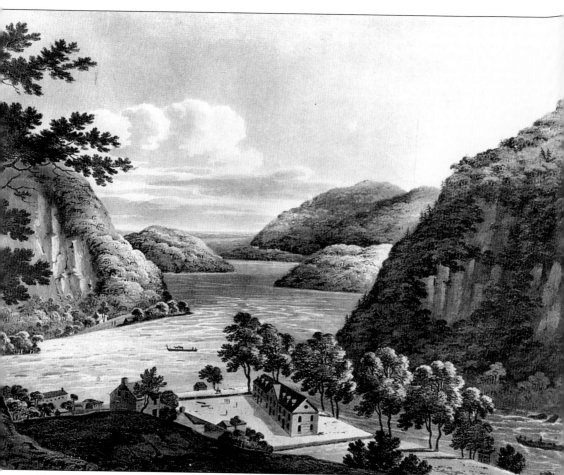

TRANQUILITY REIGNS SUPREME. In this 1808 artist's rendition of Harpers Ferry, we see the town at its idyllic best. The large arsenal is pictured in the foreground, and in the background a ferry transverses the seemingly tranquil Potomac River that is bordered on the left by Maryland Heights and on the right by Loudoun Heights. Gliding peacefully down the Shenandoah River to the right is a gundalow. Thomas Jefferson stated, "This scene is worth a voyage across the Atlantic," when he visited in 1783. Such a tranquil scene would not oft be repeated in the tumultuous history of Harpers Ferry. (Courtesy of Collection of the Museum of Early Southern Decorative Arts, Winston-Salem, North Carolina.)

IMAGES
of America

HARPERS FERRY

Dolly Nasby

ARCADIA

First published 2004
Reprinted 2004

Published by Arcadia Publishing
Charleston SC, Chicago IL, Portsmouth NH, San Francisco CA

Printed in Great Britain

Library of Congress Catalog Card Number: 2003114292

For all general information contact Arcadia Publishing at:
Telephone 843-853-2070
Fax 843-853-0044
E-mail sales@arcadiapublishing.com
For customer service and orders:
Toll-Free 1-888-313-2665

Visit us on the internet at http://www.arcadiapublishing.com

CONTENTS

Acknowledgments 6

Introduction 7

1. Once Upon a Time 9

2. The Raid 13

3. Secret Six and Raiders 23

4. Civil War 39

5. Virginius Island and Industries 53

6. Town and Historic Buildings 63

7. Transportation 91

8. Floods in Harpers Ferry 105

9. Storer College 115

10. Harpers Ferry Today 121

Bibliography 128

ACKNOWLEDGMENTS

For any historical scholars who are experts on Harpers Ferry and the Civil War, I must acknowledge that I know very well that what I am presenting in these pages is a small fraction of the story. These few pages cannot do justice to the history of Harpers Ferry, and there is no way to include it all. What I have tried to create is a pictorial history of Harpers Ferry, based on the sources available to me, and I apologize for anything I may have omitted, facts or pictures left out, or any errors I have made. My goal was to create a pictorial history that people could glance at to either relive their visit to Harpers Ferry, West Virginia, or to quickly understand the history of the town.

I wish to thank several people for their assistance in my endeavor. First, Nancy Hatcher, the librarian at the Harpers Ferry National Historical Park, was irreplaceable. I greatly appreciate her help and the help of others in the park office, such as Rich Raymond. Moreover, I have to say a very special thanks to Cari YoungRavenhorst, who taught me the difference between a "tif" and a "jpeg" file, which I never could have managed without her. I would also like to thank Arcadia for this opportunity and for all of the assistance they have given me. Of course, I want to thank my husband, who tolerated many nights and days by himself while I either did my research at the park library or typed the text into my computer.

I have been careful to document my sources as best I could, but I may have made mistakes, and I apologize if I have. Please notify the publisher if you find errors, and please cite your sources to assist me.

I also want to express great appreciation for the National Park Service and what it does for everyone. Without the park service and its dedicated employees, our past would be lost and that would be tragic. Our history is ours to share and preserve for future generations.

I dedicate this book to all historians, teachers, students, and lovers of history, and, most of all, to my family. I only wish my parents were still here to see the result of my endeavors—they would be very pleased.

INTRODUCTION

At first glance, Harpers Ferry may appear to be just like any other restored little town in America—pristine brick or cobblestone streets, attractive buildings that have been restored to a specific time period, quaint little shops for browsers, and two lovely rivers that quietly meander by. Walking the streets today and enjoying the solitude of the town, one would never guess the tumult, mayhem, and pandemonium that this town has experienced. It is only as you start to visit the exhibits that you realize that this small town was the hotbed of so much of American history.

The town's identity as a ferry crossing began when Peter Stephens settled in "The Hole" (Harpers Ferry) and established a crossing across the Potomac River in 1733. Purchased by Robert Harper in 1747, it became know as "Shenandoah Falls at Mr. Harper's Ferry" and served as a way west for Americans desiring expansion. Eventually, the name would evolve into Harpers Ferry, without the apostrophe.

Thomas Jefferson visited and declared that the beauty found in Harpers Ferry was worth the voyage across the Atlantic, thereby forever endearing Harpers Ferry to lovers of landscape and natural beauty. Many people are driven to climb the strenuous hill to Jefferson Rock today and to witness and photograph the same scene that Jefferson saw. Climbing the stone steps up past St. Peter's Catholic Church, past St. John's Episcopal Church ruins to Jefferson Rock, you let your imagination run wild as you imagine what has gone on before on these same steps, many years ago.

President George Washington put the little town on the map because he chose Harpers Ferry as one of only two places where he placed federal arsenals. In addition to the arsenal, many other businesses took advantage of the waterpower available to them along the Potomac and Shenandoah Rivers and settled on Virginius Island, creating a little entity unto itself.

For all the good that water did, it also wrought death and destruction on both the town and Virginius Island, eventually destroying all of the businesses that were once on the island and driving all of the island residents away. The lower town itself has experienced 46 recorded floods and possibly many more before history was officially recorded. The flooding may be why Native Americans used this area for hunting, instead of villages.

Harpers Ferry became a transportation hub as two major railroads came through town. The railroads brought people to visit, to live, and to work. At the peak, Harpers Ferry had 28 trains per day stopping at the stations, bringing guests, news, and commerce. In addition, the Chesapeake and Ohio Canal system brought people and goods from far and wide to Harpers Ferry.

Just as the arsenal once put Harpers Ferry on the map in a positive way, it also holds a spot in history as the seat of insurrection, as John Brown and his Raiders tried to capture it. That failed attempt to establish a provisional government and free all the slaves would lead to the greatest civil disturbance this country may ever know, the Civil War, which pitted brother again brother, father against son. Harpers Ferry suffered greatly and exchanged hands eight times, with each retreating army destroying what little of value was left.

When the dust settled and the war was over, Harpers Ferry lay in shambles, a shadow of the former town. As the residents returned home, they were devastated by what they saw. In addition, they returned home not to Virginia but to a new state, the 35th State of the Union, West Virginia, which had been created on June 20, 1863. The town did not fail but survived and is today a picturesque community, host to residents and tourists alike.

One of the greatest things that resulted from the Civil War was the establishment of Storer College. Established as a school for freedmen, it developed into an upstanding institution of higher learning that accepted students regardless of race, sex, or religious affiliation. Sadly, it is closed today, but the buildings where classes were once held are still visible and stand as a tribute to its success, as do its graduates.

In 1944 Harpers Ferry was established as a national historical park, guaranteeing her a place in the future. In the 1960s Harpers Ferry National Historical Park set a goal to restore the buildings and appearance of the lower town to that of 1859, the time of John Brown's Raid and capture.

Harpers Ferry has an undaunted and impervious spirit and will continue to thrive. The town has found its niche in today's world based on the part it played in American history. It sits as an example of fortitude and perseverance in hard times. The town has come back to life as many times as people thought it would be destroyed. Today, it stands as a shining example for all of the small historic towns across the United States.

One

ONCE UPON A TIME

About 300 years before Columbus made his historic voyage, Native American tribes used the region as hunting grounds. Their artifacts would later be found by settlers and explorers.

In 1699, John Lederer and his companions were the first Europeans to visit. In 1733, trapper and trader Peter Stephens settled in "The Hole" (Harpers Ferry) and established a ferry service across the Potomac. Robert Harper purchased the ferry from Stephens in 1747 and changed the town's history forever. In 1763, the Virginia General Assembly established the town of "Shenandoah Falls at Mr. Harper's Ferry."

Thomas Jefferson visited in 1783 and composed an eloquent description of the scene from atop Jefferson Rock stating that it is worth the voyage across the Atlantic. President Washington, determined that the government needed an armory and arsenal, decided that Springfield, Massachusetts, in the North, and Harpers Ferry, Virginia (now West Virginia), in the South, should hold the arsenals. In 1796 the U.S. government purchased 118 (one source says it was 125) acres from Harper's heirs. Harper's heirs retained two parcels of land, which later became the heart of Lower Town.

In 1859 the famous John Brown Raid occurred. During the Civil War, the little town of Bolivar, adjacent to Harpers Ferry and where Camp Hill was located, witnessed the largest Union surrender in the Civil War when 12,000 troops were captured.

Harpers Ferry was established as a national historical park in 1944, thereby guaranteeing the town a future while preserving its past. Later, the National Park Service established a goal to restore the town to its 1859 appearance, which is how it remains today.

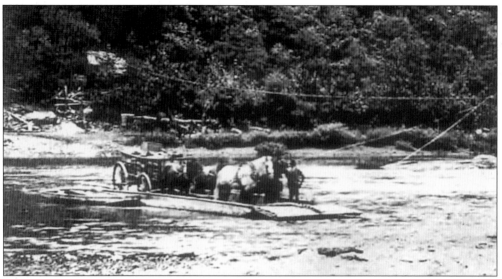

FERRY ACROSS THE SHENANDOAH RIVER. The completion of a new Shenandoah River bridge in 1882 made this ferry obsolete. This photograph shows a rope ferry with a wagon and a team of horses crossing the Shenandoah River between 1876 and 1881 (or between 1889 and 1893). The ferry operated before any bridges were built and ran periodically when the bridges were damaged or closed by floods, such as between 1889 and 1893. (Courtesy of the Library of Congress, Thomas Featherstonhaugh Collection.)

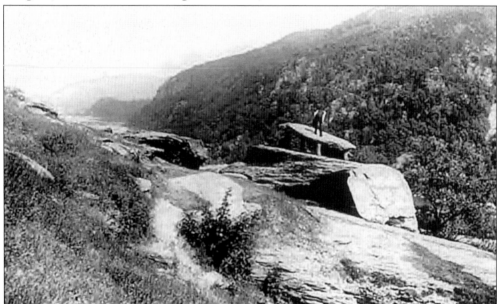

JEFFERSON ROCK. This July 31, 1890 photograph shows a tourist standing atop Jefferson Rock. On October 25, 1783, Thomas Jefferson stood on top of the rock shown here, looked out over the landscape, and uttered the eloquent words, "This scene is worth a voyage across the Atlantic." The words, recorded in his *Notes on the State of Virginia*, would forever endear Jefferson to Harpers Ferry residents and draw tourists to the beauty of Harpers Ferry. Today this rock is called "Jefferson Rock." (Courtesy of the Historic Photograph Collection, Harpers Ferry National Historical Park.)

PRESIDENT THOMAS JEFFERSON.
It was Thomas Jefferson who
commissioned the group of
explorers, called the Corps of
Discovery, to explore the recently
acquired Louisiana Purchase.
The goal of this expedition was to
cross the continent looking for
the fabled Northwest Passage.
Before their departure, much
preparation was needed, including
acquiring necessary arms and
supplies. Much of the arms and
supplies came from Harpers Ferry.
(Courtesy of the Library of
Congress, America's Story, artist
Gilbert Stuart, "Thomas Jefferson,
Third President of the United
States." 1828[?]. "By Popular
Demand: Portraits of the Presidents
and First Ladies, 1789–Present,"
Library of Congress.)

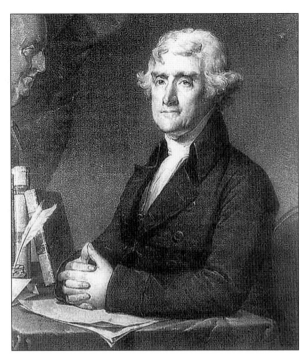

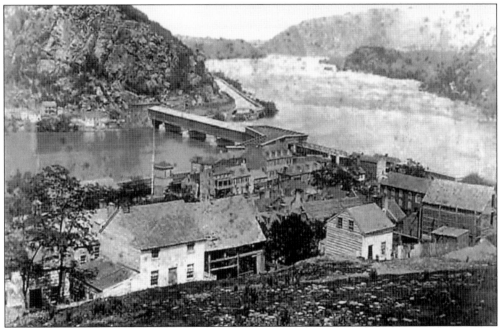

EARLIEST KNOWN PHOTOGRAPH OF HARPERS FERRY. Taken in 1859, this is one of the earliest
known photographs of Harpers Ferry and the covered Baltimore & Ohio Railroad Viaduct. This
was the bridge that John Brown and his Raiders would cross, unseen, but not unheard, by the
residents of Harpers Ferry. At this time, The Point was the hustling, bustling commercial center
of the town. From this point on, Harpers Ferry would see nothing but change and destruction
until the end of the Civil War. (Courtesy of the Historic Photograph Collection, Harpers Ferry
National Historical Park.)

Boat Model. Tourist Gen Rokosky, from Homer City, Pennsylvania, stands beside a model of the frame of a boat that was designed for the Lewis and Clark Expedition. Armory mechanics had difficulty assembling the frame, and Lewis had to stay an extra month instead of the originally planned week. On the expedition, when the boats were needed, the frames were reassembled and covered with four buffalo skins and 28 elk skins. No pitch was available from pine trees, so a combination of beeswax, buffalo tallow, and charcoal was applied to keep the skins from leaking. However, the boat leaked, and they were forced to abandon the idea. (Photo by Walter Wojcik.)

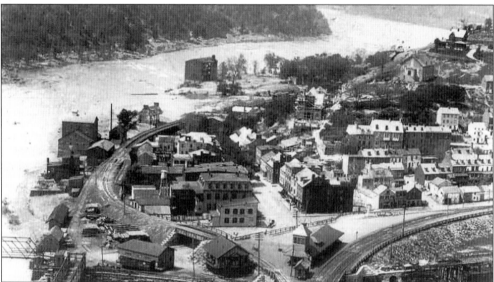

Lower Town, 1896. Taken in 1896, this view shows the lower town of Harpers Ferry and The Point, as seen from Maryland Heights. Two years before, the passenger depot and the mainline track for the Baltimore and Ohio Railroad had opened. The construction of the B&O RR mainline track had led to the creation of a 20-foot embankment, which covered the Old Armory Grounds. In addition, in the upper left of the photograph there is a good view of Virginius Island. Also evident is the remodeling of St. Peter's Catholic Church. (Courtesy of the Historic Photograph Collection, Harpers Ferry National Historical Park.)

Two

THE RAID

On Sunday October 16, 1859, John Brown led his Raiders in a worship service in the living room of the Kennedy Farmhouse. At 8 p.m., he called his men to arms. It was moonless, chilly, overcast, and drizzling as they headed to Harpers Ferry. They cut the telegraph wires, captured the armory and arsenal. Hall's Rifle Works, which supplied weapons for the U.S. government, was secured. It was here that the first shot of the raid was fired—watchman Patrick Higgins was shot by a raider after Higgins struck raider Watson Brown, son of John Brown.

Prominent citizens were taken as hostages—Col. Lewis W. Washington, great grandnephew of George Washington, along with John Alstadt and some slaves. Brown expected the slaves to join the fight; however, because of his demand for secrecy the slaves knew nothing of his plans.

At 1:25 a.m., a B&O passenger train arrived. It was halted and Heyward Shepherd, a station baggage man, was shot. Ironically, the first person to die in the raid to free slaves was himself a freed slave. Brown allowed the train to continue to Monocacy, Maryland. President Buchanan, Virginia Governor Wise, Major General Stewart, and the Frederick Militia were notified.

The Charlestown (later "Charles Town") militia arrived. Brown's escape route was cut off. Brown sent out a truce flag that was ineffective. He sent out another truce flag with raider Stevens, raider Watson, and the acting superintendent. Both Raiders were shot, and the superintendent was able to escape. Watson Brown was able to crawl back to the engine house. More militia arrived and again Brown tried to negotiate, but to no avail.

Ninety U.S. Marines arrived, led by Robert E. Lee and assisted by J.E.B. Stuart. At 2:30 a.m. Stuart delivered a surrender demand that was refused. Brown counter-offered and was refused. As Stuart signaled with a wave of his hat, Lieutenant Green and 12 men stormed the engine house. Three minutes later, it was over. Brown was captured, and no hostages had been injured, but history was changed forever.

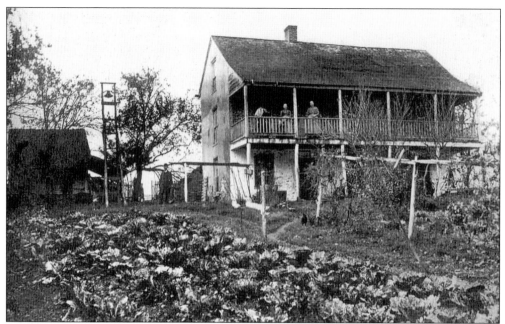

KENNEDY FARM HOUSE. John Brown used this farm as headquarters and a hideout during the spring and summer of 1859. He rented it from the heirs of Dr. Booth Kennedy. It was located seven miles from the Maryland side of the Potomac in Washington County, Maryland. He rented it for $35 in gold under the name of Isaac Smith, and stated that he was a cattle buyer from New York. On the second story porch two women and another unidentified person can be seen. On the left side of the building, a man can be seen standing between the bell tower and the house, with the vegetable garden in front. (Courtesy of the Thomas Featherstonhaugh Collection of the Library of Congress.)

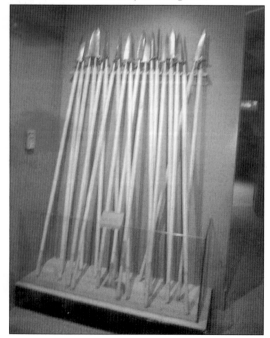

PIKES. John Brown ordered at least 1,000 pikes like these. He was concerned that the slaves would not know how to use rifles but thought they could handle and would feel more comfortable with pikes. He also felt that the slaves would enthusiastically accept his rebellion; however, this did not happen. He had kept the raid so secretive that the slaves had not heard about it. (Photo by Dolly Nasby.)

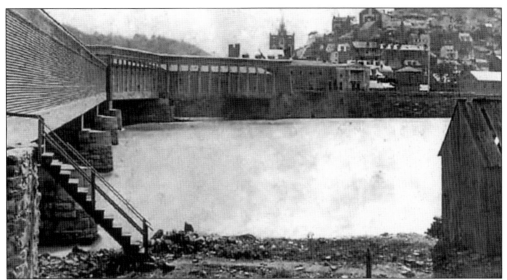

COVERED BRIDGE. This remarkable photograph shows the Harpers Ferry and Potomac River Bridge from the Maryland Shore. This is the bridge that John Brown crossed the night of his raid in 1859. It would later be destroyed by Confederate forces on June 14, 1861. The bridge was erected in 1836 but was not covered with weatherboard siding and a tin roof until 1847. In the distance can be seen the B&O water tower, armory flagpole, and a musket factory building. In addition, on the hill can be seen St. Peter's Catholic Church and St. John's Episcopal Church. (Courtesy of the Historic Photo Collection, Harpers Ferry National Historical Park.)

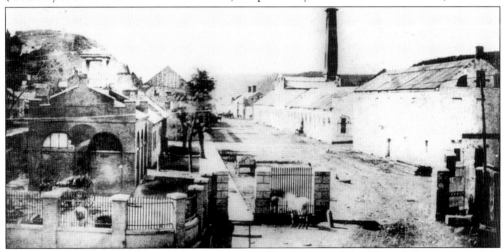

ARMORY, 1865. This photograph is of the musket factory of the United States armory at Harpers Ferry. It was taken after John Brown's Raid, but it shows the location of the engine house with regards to other buildings. Famous Civil War photographer Matthew Brady probably shot this image, although that is not certain. The photograph shows buildings that were used as a quartermaster depot. Brown would keep his hostages in the fire engine house to the left. On the right were machine shops where muskets were assembled. This is the main entrance to the musket factory yard. This view shows good details of the fence and wall construction as well as the intact fire engine house. Maj. John Symington designed the factory yard. The flat factory yard was created with fill dirt. (Courtesy of the Historic Photo Collection, Harpers Ferry National Historical Park.)

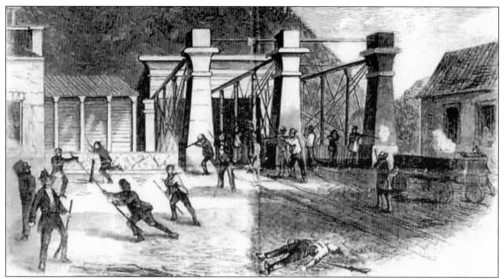

ATTACK BY RAILROAD MEN. This is a sketch of fighting by the railroad men during the raid on Harpers Ferry, led by John Brown. This bridge, constructed between 1850 and 1852, was known as the "Winchester Span" because the Winchester and Potomac Railroad traversed it. This shows the railroad men attacking the insurgents. The rocky cliffs of Maryland Heights can be seen on the far side at left and center. (Courtesy of the Historic Photo Collection, Harpers Ferry National Historical Park.)

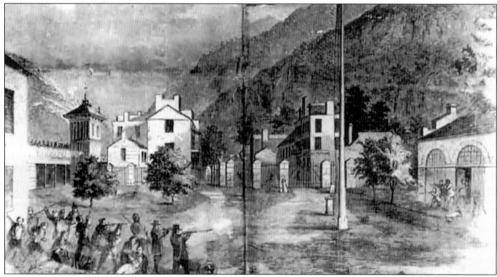

MILITIA VOLUNTEERS ATTACK. Militia volunteers attacked Brown's men at the fire engine house near the armory gate. Some of the units that tried to quell the raid at various times during the day include Shepherdstown, Charles Town, Winchester, Martinsburg (all from Virginia), Frederick, and at least four other companies from Maryland. Capt. E.G. Alburtis led the militia from Martinsburg, who were mostly railroad workers, and stated that if other militia would have helped them, the raid would have ended sooner. None of the militia were organized enough to dislodge Brown from the engine house—they all contributed to the confusion and hysteria in the town. This image first appeared in Frank Leslie's *Illustrated Newspaper* November 5, 1859. (Courtesy of the Historic Photo Collection, Harpers Ferry National Historical Park.)

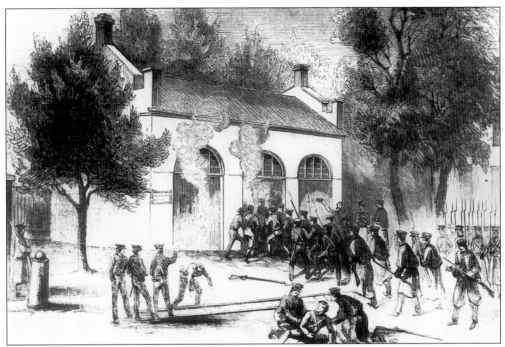

MARINES STORMING ENGINE HOUSE. This is a drawing by Porte Crayon done in 1859. It depicts the U.S. Marines as they stormed the engine house, October 1859. The marines were led by Gen. Robert E. Lee, who was assisted by volunteer James Ewell Brown (J.E.B.) Stuart, both of whom went on to become important Civil War officers for the Confederacy. (Courtesy of the Historic Photo Collection, Harpers Ferry National Historical Park.)

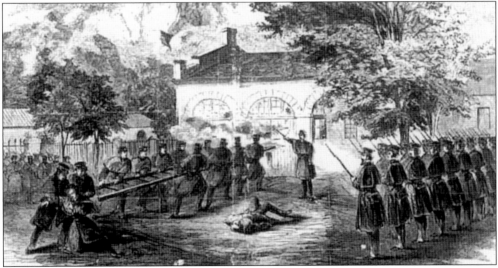

STORMING THE FORT. This illustration first appeared in November 1859 in *Harper's Weekly*. It depicts the U.S. Marines storming the engine house. The Raiders are firing through holes in the walls. There were 90 marines present but only 12, plus a leader, participated in the final ousting of John Brown and his Raiders from the engine house. This shows the Marines using a ladder to break down the door of the engine house. They first tried to use a sledgehammer, but that effort failed. (Courtesy of the Historic Photo Collection, Harpers Ferry National Historical Park.)

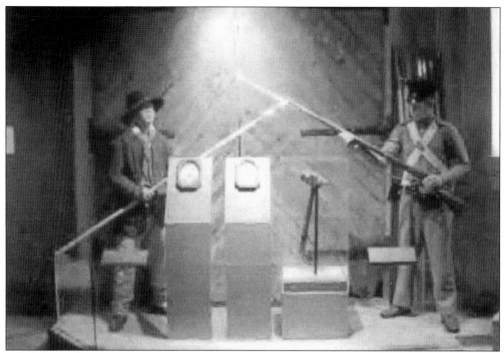

ENGINE HOUSE DOORS. These are the doors of the engine house that were broken down by the marines. First, they tried to break the doors down with the sledgehammer pictured here. When that failed, they used a heavy ladder as a battering ram, which splintered the doors enough for them to gain entry. (Courtesy of the Don Worth, CivilWarAlbum.com, Home Page.)

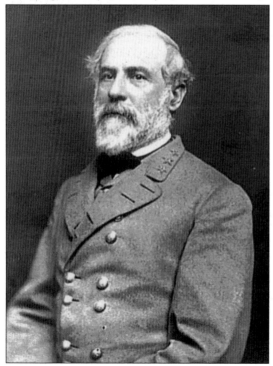

ROBERT E. LEE. This is a portrait of Gen. Robert E. Lee when he served as an officer of the Confederate Army. Before the formation of the Confederate States of America, Lee had led the U.S. Marines as they captured John Brown and his Raiders in the engine house at Harpers Ferry, Virginia, in October 1859. During that attack, J.E.B. Stuart assisted him. (Courtesy of The Civil War Home Page, www.civilwarphotos.net/files/ images/627.jpg., [Portrait of Gen. Robert E. Lee, officer of the Confederate Army], Julian Vannerson, 1863. LC-B8172-0001.)

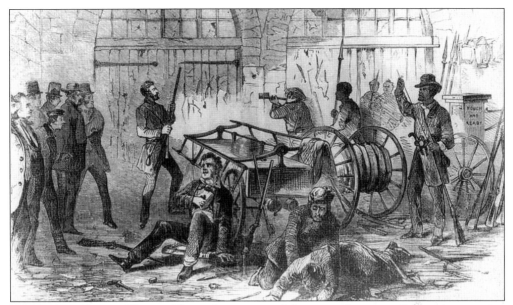

INTERIOR OF ENGINE HOUSE. This is the interior of the engine house just before the storming party broke down the gate on October 18, 1859. Colonel Washington and his associates are captives, held by Brown as hostages. Brown is standing to the left of the wagon, holding the gun. Two Raiders are seen lying on the floor, dying. This was sketched by artist Alfred Berghaus for Frank Leslie's *Illustrated Newspaper*, New York, November 5, 1859. Berghaus was sent to Harpers Ferry to cover the raid. (Courtesy of the Historic Photo Collection, Harpers Ferry National Historical Park.)

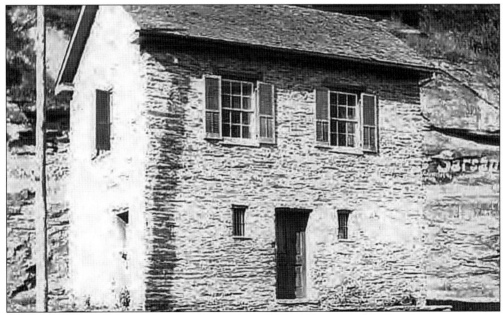

POTOMAC RIVER JAIL. After they first captured John Brown, but before he was taken to Charles Town Jail, he was taken to the Potomac River Jail in Harpers Ferry. The building is no longer standing but once stood along Shenandoah Street. (Courtesy of the Historic Photo Collection, Harpers Ferry National Historical Park.)

CHARLES TOWN JAIL. Before John Brown was transferred to this jail, he was held briefly in the Potomac River Jail in Harpers Ferry. He was arrested on October 18, arraigned on October 25, indicted on October 26, and his trial began on October 27. The trial lasted three and a half days; he was sentenced on November 2 and hanged on December 2, 1859. (Courtesy of the Thomas Feathersonhaugh Collection, Library of Congress.)

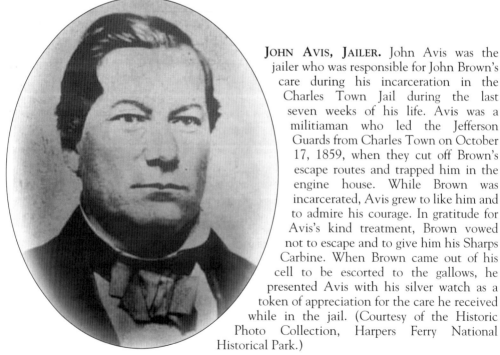

JOHN AVIS, JAILER. John Avis was the jailer who was responsible for John Brown's care during his incarceration in the Charles Town Jail during the last seven weeks of his life. Avis was a militiaman who led the Jefferson Guards from Charles Town on October 17, 1859, when they cut off Brown's escape routes and trapped him in the engine house. While Brown was incarcerated, Avis grew to like him and to admire his courage. In gratitude for Avis's kind treatment, Brown vowed not to escape and to give him his Sharps Carbine. When Brown came out of his cell to be escorted to the gallows, he presented Avis with his silver watch as a token of appreciation for the care he received while in the jail. (Courtesy of the Historic Photo Collection, Harpers Ferry National Historical Park.)

CHARLES TOWN COURT HOUSE.
John Brown was tried in this courthouse in Charles Town, then a part of Virginia, today West Virginia. The trial began on October 27, 1859, and lasted only three and a half days. He was sentenced on November 2 and hanged on December 2. The other captured Raiders were tried here as well. Charlestown was the county seat and named for Charles Washington, the youngest brother of George Washington. Charles moved to the area in 1870. His home was known as Happy Retreat and was a favorite rest stop for the wealthy and famous. The town's name was originally Charlestown, not Charles Town, as it is known today (not to be confused with Charleston, the capital of West Virginia today). (Courtesy of the Thomas Featherstonhaugh Collection, Library of Congress.)

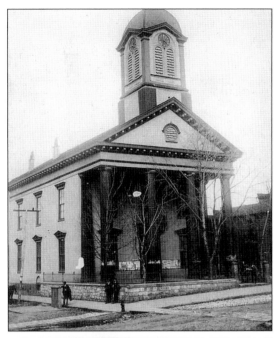

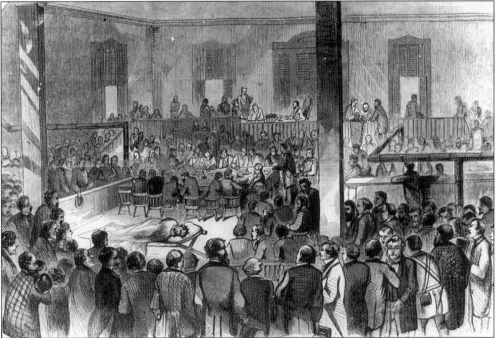

TRIAL OF JOHN BROWN. John Brown was tried for treason and found guilty in this Charles Town courthouse in October 1859. Brown was injured when the engine house was attacked. Lieutenant Green was the first man through the door and raised a sword over Brown. He brought it down on him, cutting deep wounds in the back of Brown's neck rendering him unconscious. When Brown was tried in the courtroom shown here, he was still suffering from those wounds and lay on a cot with his hair matted with dried blood. Porte Crayon sketched the scene. (Courtesy of the Historic Photo Collection, Harpers Ferry National Historical Park.)

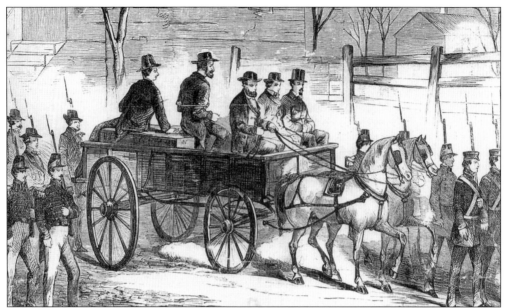

EN ROUTE TO HANGING. This sketch, drawn December 2, 1859, the day of John Brown's execution shows him riding on his own coffin to his execution, which took place in a stubble field near the home of Col. Charles Washington. His wounds, which he acquired when he was captured on October 18, 1859, were partially healed by this time. (Courtesy of the Historic Photo Collection, Harpers Ferry National Historical Park.)

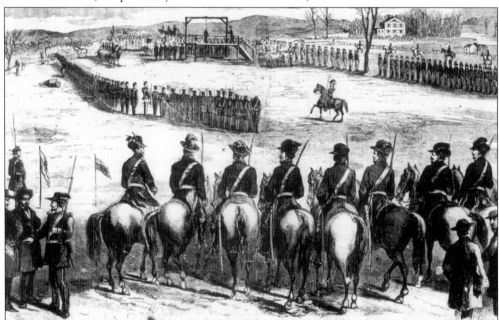

JOHN BROWN HANGING. The execution by hanging of John Brown is depicted here in a sketch by an unknown artist. The December 2, 1859 sketch shows the stubble field with 1,500 troops in attendance, with "Happy Retreat," the home of Col. Charles Washington in the background. The military personnel appear to be wearing their dress uniforms. (Courtesy of Historic Photo Collection, Harpers Ferry National Historical Park.)

Three

SECRET SIX AND RAIDERS

John Brown could not have completed the raid on Harpers Ferry without the help of two groups: the Secret Six and the Raiders. The financial backing of the Secret Six was essential. They met periodically and secretly to arrange the necessary funding. What John Brown wanted to accomplish would have been impossible without the backing of the six well-to-do New Englanders: Franklin B. Sanborn, George Luther Stearns, Samuel Gridley Howe, Gerritt Smith, Thompson Wentworth Higginson, and Theodore Parker.

The Raiders, who joined John Brown's cause, were a varied lot and all were fiercely loyal to him and the abolitionist cause. They all felt there was no compromise on slavery—it had to be removed, through violent means if need be, and they would risk their lives for that cause. Of those 21 men, 19 were under the age of 30 and three were not yet 21. Once caught and imprisoned, they pretended not to know John Brown in the hopes that the guards would think they had the wrong men and release them.

Before the raid began, Brown conducted a final worship service. He instructed his men to defend themselves, but not to shed blood unnecessarily. All knew the risks.

Brown knew there was a chance for failure. He also knew that the raid might be the impetus that would create a sectional division in the country, and the country might very well go to war over the issue, which is what happened.

We remember the Raiders today as brave individuals who were willing to stand up for what they believed. They could not have been braver men.

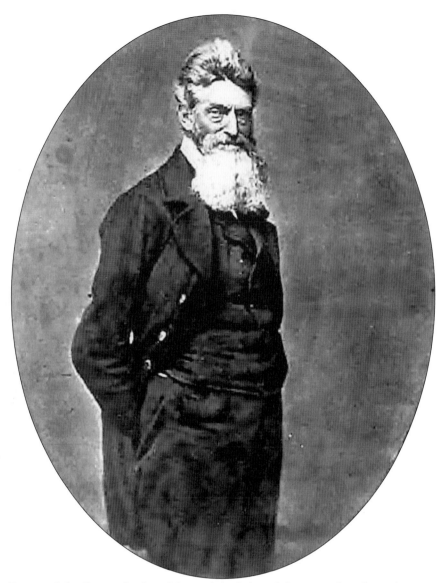

JOHN BROWN. John Brown, leader of the raid, both hated slavery and made its destruction his life goal. He thought that he was an instrument of God. Prior to the raid on Harpers Ferry, Brown was known by authorities as "Ossawatomie Brown" from his exploits in Kansas. Brown and his followers had killed several pro-slavery people in Kansas and received the nickname because the murders had been committed near the Ossawatomie River in 1856. According to John, the murders had been committed in accordance with "God's Will." During the raid on Harpers Ferry, watchman Patrick Higgins wounded Brown, and Brown was carried to the paymaster's office. Questioned for three hours by Virginia's governor, Henry A. Wise, Sen. James M. Mason, and Ohio congressman Clement L. Vallandigham, Brown told the purpose of the raid but would not reveal his supporters' names. Jailed in Charles Town, arraigned on October 25, and indicted for treason on October 26, he plead not guilty. The trial began on October 27 and lasted three-and-a-half days. He was sentenced on November 2 and hanged on December 2, 1859. (Courtesy of the Historic Photo Collection, Harpers Ferry National Historical Park.)

THOMPSON WENTWORTH HIGGINSON. Secret Six member Higginson was a Massachusetts Unitarian minister who came to believe violence was necessary to remove slavery—he even resigned as pastor so that he could write and lecture for the cause of disunion, predicting that a revolution was coming. At the age of 13, he attended Harvard where he met Theodore Parker. Later, at Harvard Divinity School, he met and formed a romantic attachment to William Hurlbert, to whom he continued to write loving letters (the custom among male friends in the Victorian era) even after he married his second cousin, a sickly, highly intelligent woman who was an invalid for most of their married life. After the raid, he refused to destroy his papers and defied anyone to arrest him. Later he became a commander of black troops in the Civil War. (Courtesy of the Historic Photo Collection, Harpers Ferry National Historical Park.)

THEODORE PARKER. Secret Six member Parker delivered such radical Unitarian sermons that most pulpits were closed to him, and he started his own church. He was an eloquent speaker, had a good wit, and was so intelligent that he mastered 19 or 20 languages and owned a library with 16,000 volumes. While he believed that slaves were intellectually inferior, he also felt slavery was a violation of God's law. Originally, he felt abolitionists too fanatical, but eventually he came to believe violence and Civil War was the only way. He held a reception for Brown in his home in Boston. He played a prominent role in resisting the Fugitive Slave Law by hiding slaves in his home and arming them. He became gravely ill with consumption (tuberculosis) and traveled to Rome, Italy, to die. (Courtesy of the Historic Photo Collection, Harpers Ferry National Historical Park.)

GERRIT SMITH. Secret Six member Smith was a millionaire landowner philanthropist from New York. He gave Oberlin College 1,000 acres and reserved 120,000 acres in the Adirondack Mountains for blacks to become property owners, thus enabling them to vote (he sold Brown 244 of those acres at $1 per acre). Other causes to which he contributed were land reform, education, temperance, and abolition of slavery. He felt that there was no hope for slaves except through God and insurrection. After the raid he was convinced he would be indicted, burned all letters that talked about the plot, went temporarily insane, and on November 7 was committed to the State Asylum for the Insane at Utica. When he found that he would not be arrested or implicated, his sanity returned and he was released. (Courtesy of the Historic Photo Collection, Harpers Ferry National Historical Park.)

FRANKLIN B. SANBORN. Secret Six member Sanborn was a schoolteacher, a graduate of Harvard, and very intellectual. He was a romantic idealist and believed without question in the abolitionist cause. He arranged interviews for Brown with George Luther Stearns and Dr. Samuel Gridley Howe and introduced him to Theodore Parker. After the raid, he spent two consecutive nights destroying papers that would implicate him. He favored having the United States go to war in order to have the South, which was unrepentant in Sanborn's eyes, go up in flames so as to remove slavery from the country. (Courtesy of the Historic Photo Collection, Harpers Ferry National Historical Park.)

GEORGE LUTHER STEARNS. Secret Six member Stearns suffered from chronic bronchitis and wore a long beard to protect his chest. He was a member of the Emigrant Aid Society and was a self-made, successful businessman from New England, who started out as a clerk. He owned a linseed oil mill, profited between $15,000 and $20,000 annually, willingly donated to benevolent causes, and encouraged his customers and colleagues to do likewise. A member of John Brown's "Secret Six," he was interrogated after the raid by a special investigating committee established on December 14 by Congress. However, questions were fashioned in such a way that he was able to answer honestly and not implicate himself. (Courtesy of the Historic Photo Collection, Harpers Ferry National Historical Park.)

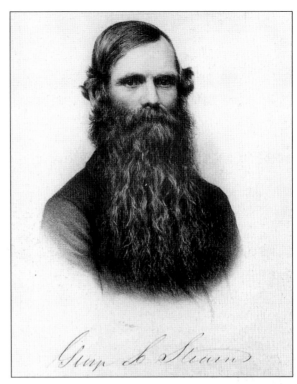

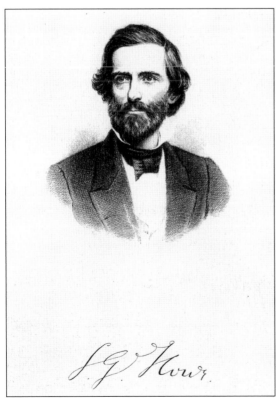

SAMUEL GRIDLEY HOWE. Secret Six member Howe was a physician, reformer, and educator, who was driven to correct social wrongs. He pioneered reforms for the education of the feeble-minded, insane, and blind, founding the Perkins' School for the Blind. An old aristocratic New Englander, he and his wife, Julie Ward Howe (who wrote the "Battle Hymn of the Republic") were co-editors of an abolitionist newspaper. He was 20 years her senior, and they fought constantly. He could not understand why she was not happy being a housewife and mother. Brown relied on Howe as the guerilla warfare expert because he had fought in the Greek Revolution and helped the Polish rebels. After the raid, he was investigated, but the committee found that Brown only received help from the Raiders. (Courtesy of the Historic Photo Collection, Harpers Ferry National Historical Park.)

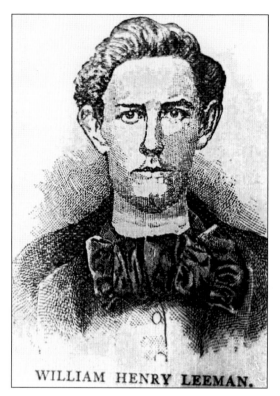

WILLIAM HENRY LEEMAN.

WILLIAM HENRY LEEMAN. William Leeman, 20, was the youngest raider. He considered slavery the greatest curse in America. Shortly before the raid, he wrote to his mother about what they were doing and what a good cause it was. When Watson and Stevens were shot while carrying a flag of truce, Leeman became frightened and escaped from the armory yard. He leaped over the gate and ran to the Potomac. He died on a small islet. His body lay there for hours, serving as target practice for militia and townsfolk. When his mother heard of his death, she went into shock and lay in bed for 18 months, unable to speak. (Courtesy of Historic Photo Collection, Harpers Ferry National Historical Park.)

LEWIS S. LEARY. Leary, 25, left his wife and six-month-old baby in Oberlin, Ohio, to help Brown. When he left, his family did not know his purpose in going to Harpers Ferry. Leary was African American and was the first Oberlin recruit in Brown's army. He was wounded during the escape from Hall's Rifle Works, tried to get across the Shenandoah River and survived for eight hours, dying the next morning in a cooper's shop. He was treated well and was able to send messages to his family, reportedly saying, "I am ready to die." He died October 17, 1859. (Courtesy of the Historic Photo Collection, Harpers Ferry National Historical Park.)

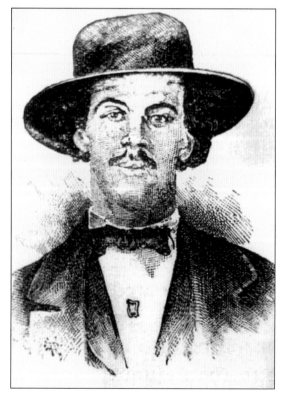

STEWART TAYLOR. Stewart Taylor, born on October 29, 1836 in Uxbridge, Canada, was the only raider who was not American by birth. He was only 23 when he was killed. For a time he lost communication with John Brown and felt that he was going to be "left out" of the John Brown Movement. He arrived some time in August. At one point, the group had disagreements, and Stewart was one of the first to return to Brown's side. He was a spiritualist and had a premonition that he would die at Harpers Ferry, which he did on October 17, 1859. He was shot in the afternoon and his body lay near the doorway of the engine house throughout the day. (Courtesy of the Historic Photo Collection, Harpers Ferry National Historical Park.)

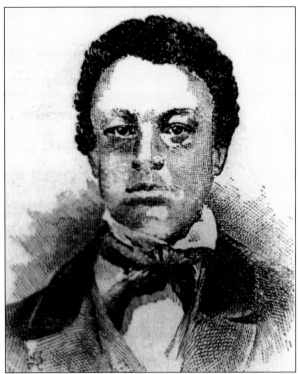

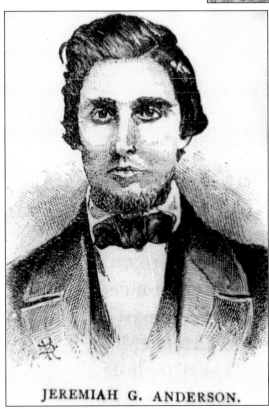

JEREMIAH G. ANDERSON.

JEREMIAH GOLDSMITH ANDERSON. Anderson was 27 when he was killed at Harpers Ferry. A grandson of slaveholders, he was determined to end slavery. He joined John Brown on a slave raid into Missouri and after, became one of his followers, later serving as a lieutenant. He wrote to his brother that they intended to win, at all costs. During the raid, marines bayoneted him. As he lay dying, an armed farmer approached him, forced his mouth open, and spat a huge quid of tobacco into his mouth. (Courtesy of the Historic Photo Collection, Harpers Ferry National Historical Park.)

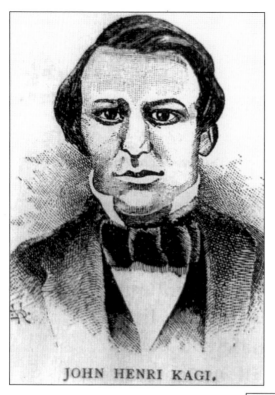

JOHN HENRI KAGI.

JOHN HENRI KAGI. Kagi was articulate, highly intelligent, and the most educated of the raiders, albeit largely self-taught. He was a correspondent for several eastern newspapers. He believed that Harpers Ferry should be taken by surprise and that the band could disappear into the mountains after the raid. Because Kagi had taught school in Virginia (now West Virginia), he was able to give Brown valuable information. Kagi and raider Stevens took watchman William Williams prisoner at the covered bridge. Later, Kagi tried to escape, was shot, and died on October 17 at age 22. His body fell into the river, perforated with bullet holes. (Courtesy of the Historic Photo Collection, Harpers Ferry National Historical Park.)

DANGERFIELD NEWBY. Newby, 44, was born a slave in Virginia. His owner and father was Scottish and freed him and his siblings. Newby wanted to free his wife, Harriet, and children from a plantation in Virginia. However, after the raid, she and her children were "sold south" to Louisiana. During the raid, Newby guarded the bridges with other raiders. He was wounded by a six-inch spike that cut his throat from ear to ear, making him the first of the raiders to die. A militiaman, half-drunk, dragged Newby into the gutter where he sliced off his ears as souvenirs. Others beat his body with sticks, and the final humiliation came when a pack of hogs came to root on the body. (Courtesy of the Historic Photo Collection, Harpers Ferry National Historical Park.)

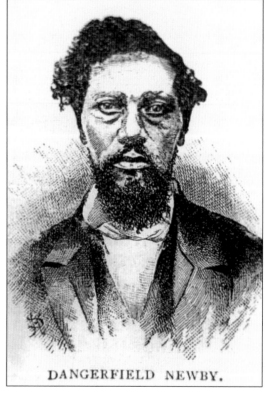

DANGERFIELD NEWBY.

WILLIAM THOMPSON. William Thompson, 26, was from New Hampshire. He married Mary Brown (no relation to the John Brown family). Thompson's sister and his brother had married John Brown's son and daughter. William and Dauphin were neighbors of Watson Brown's in North Elba, and the three of them arrived together. At one point during the raid, Brown sent him out along with a prisoner under a flag of truce. The crowd seized William Thompson and took him off at gunpoint. William was pulled out by the throat, dragged by the mob, and shot in the head. His body was then thrown into the river and used as target practice throughout the day. His body was later recovered and buried. (Courtesy of the Historic Photo Collection, Harpers Ferry National Historical Park.)

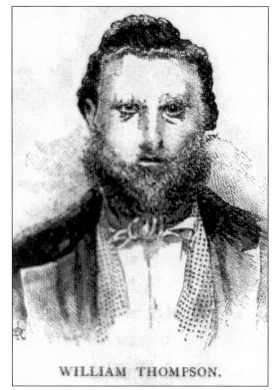

WILLIAM THOMPSON.

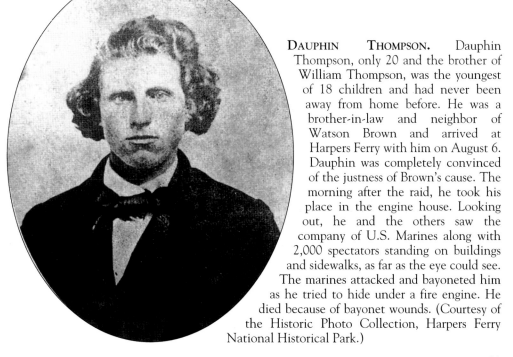

DAUPHIN THOMPSON. Dauphin Thompson, only 20 and the brother of William Thompson, was the youngest of 18 children and had never been away from home before. He was a brother-in-law and neighbor of Watson Brown and arrived at Harpers Ferry with him on August 6. Dauphin was completely convinced of the justness of Brown's cause. The morning after the raid, he took his place in the engine house. Looking out, he and the others saw the company of U.S. Marines along with 2,000 spectators standing on buildings and sidewalks, as far as the eye could see. The marines attacked and bayoneted him as he tried to hide under a fire engine. He died because of bayonet wounds. (Courtesy of the Historic Photo Collection, Harpers Ferry National Historical Park.)

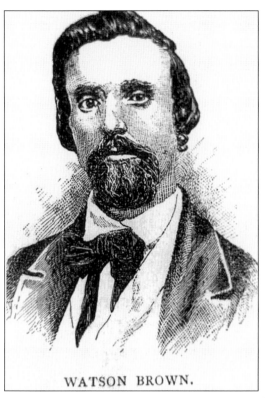

WATSON BROWN.

WATSON BROWN. Watson both feared and tried to emulate his father's ideals. At 21, he married Isabelle M. Thompson. He came to the Kennedy Farm with William and Dauphin Thompson, leaving his newborn son and wife in North Elba. His father sent Watson, Stevens, and the acting armory superintendent Kitzmiller out carrying a white flag in an attempt to surrender during the raid, but they were fired upon and both raiders were wounded. Watson dragged himself back to the engine house where he later died at age 24. His body was given to Winchester Medical College. When asked what brought him to Harpers Ferry, he replied, "Duty." His widow later married Salmon Brown, Watson's cousin. (Courtesy of the Historic Photo Collection, Harpers Ferry National Historical Park.)

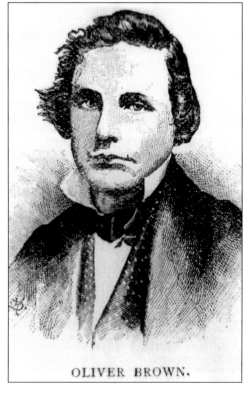

OLIVER BROWN.

OLIVER BROWN. Oliver was the youngest son of John Brown and not pleased with the plan—he also knew not to disobey his father. He thought the terrain might trap them and make escape impossible. After Oliver, Newby and William Thompson were routed from the bridges they were guarding, and they barricaded themselves in the Wager House. Oliver made it to the armory, was shot, and lay on the engine room floor begging his father to end his misery. His father reportedly snapped, "If you must die, then die like a man." Buried on the banks of the Shenandoah, Oliver was later exhumed and sent to North Elba in 1899. (Courtesy of the Historic Photo Collection, Harpers Ferry National Historical Park.)

AARON DWIGHT STEVENS. Stevens was using the name Whipple when he met John Brown. He confessed to his sister that he would be willing to die for the oppressed. He helped take watchman William Williams prisoner, then led another group to the rifle factory, easily capturing that watchman. He and Watson Brown were shot while carrying a flag of truce. A hostage helped Stevens to the paymaster's office for medical attention. Ironically, the hostage then returned to his captors. Stevens was arraigned October 25, indicted for treason October 26, and had to be supported by two bailiffs because his wounds were so severe. Stevens shared a cell with John Brown. He was tried and found guilty. (Courtesy of the Historic Photo Collection, Harpers Ferry National Historical Park.)

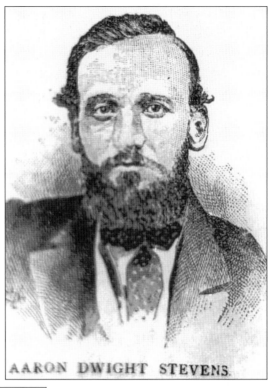

AARON DWIGHT STEVENS.

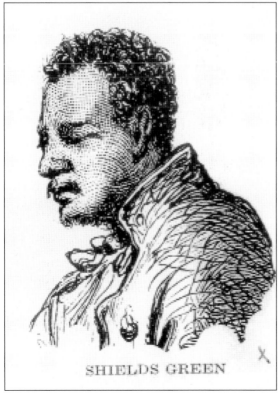

SHIELDS GREEN

SHIELDS GREEN. "Emperor" Shields Green was illiterate and a fugitive slave from South Carolina. His good friend, Frederick Douglas, who had refused to participate in the raid, introduced him to John Brown. When the three of them were together, Douglas asked Green what he wanted to do and he replied that he would go with Brown. The morning after the raid, Green took his position in the engine house. The marines attacked and the raiders were captured, Green surrendered and was jailed in Charles Town. He was arraigned October 25, indicted for treason October 26, and stood trial. George Sennott, a young lawyer from Boston, had tried to save the fugitive slave's life but to no avail. Green was found guilty of murder and conspiring slaves to rebel. He was 23. Governor Wise would not release the body of the slave unless white men came to get it. (Courtesy of the Historic Photo Collection, Harpers Ferry National Historical Park.)

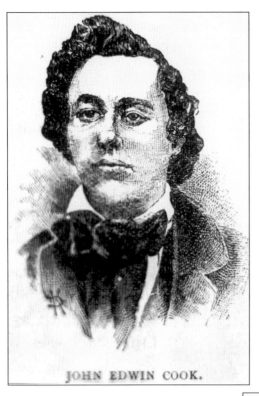

JOHN EDWIN COOK.

JOHN EDWIN COOK. Cook, from a wealthy Connecticut family, attended Yale and studied law in New York and Brooklyn. He went to Harpers Ferry a year early to learn about the people, the Armory and the Arsenal, but was given stern orders to keep his mouth shut because he tended to talk excessively. He was a ladies man and eventually Mary Kennedy became pregnant. He married her in April of 1859 and became a father a few months later. Cook mistakenly reported that slaves would "swarm like bees." Cook escaped, was captured near Chambersburg, Pennsylvania, on October 27. While in jail, he wrote a confession for which he was termed the "Judas" of the raid. He was convicted and hanged December 16, 1859, in Charles Town. (Courtesy of the Historic Photo Collection, Harpers Ferry National Historical Park.)

JOHN ANTHONY COPELAND JR. Copeland was a free black man from North Carolina. He, Kagi, and another African American were driven from Hall's Rifle Works towards the Shenandoah as the militia pursued them. They all knew better than to surrender. The crowd wanted to lynch him, but a local physician, Dr. Starry, shielded him with his horse. Copeland was arraigned on October 25, indicted for treason October 26, tried, found guilty of murder and conspiring with slaves to rebel, and executed December 16, 1859. The prosecuting attorney stated that Copeland was one raider he would have picked out for pardon. Governor Wise would not release any African-American bodies until white men came to get them. (Courtesy of the Historic Photo Collection, Harpers Ferry National Historical Park.)

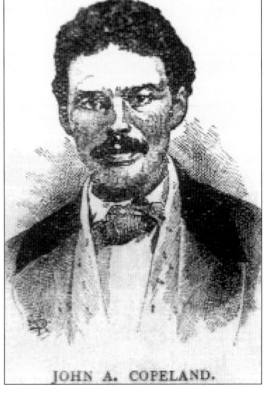

JOHN A. COPELAND.

EDWIN COPPOC. Edwin Coppoc, a Quaker, was living with his brother Barclay and his mother in Springdale. During the raid, he believed the mayor was aiming at John Brown so Edwin took aim, shot, missed, and shot again, killing the mayor. Ironically, the mayor's will stated that upon his death, his slave Isaac with wife and three children would be freed. The next morning Edwin saw 2,000 spectators on buildings and sidewalks as far as the eye could see. He surrendered in the engine house, was jailed, arraigned October 25, indicted for treason October 26, tried, and found guilty. He insisted that he did not know of the plan to seize the Arsenal. He claimed he saw 800 people visit the jail over two days. He was hanged December 16, 1859. (Courtesy of the Historic Photo Collection, Harpers Ferry National Historical Park.)

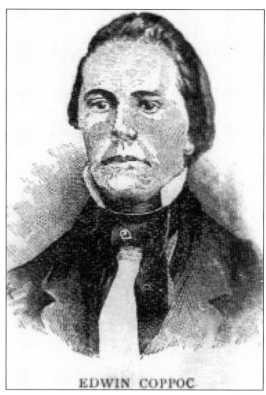

EDWIN COPPOC

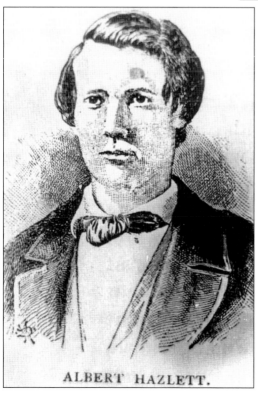

ALBERT HAZLETT.

ALBERT HAZLETT. Albert Hazlett was from Pennsylvania and before the raid worked for his brother on a farm. After the raid, he was able to escape by mingling with the wild and unruly crowd. He was arrested in Carlisle, Pennsylvania, where he went by the alias William H. Harrison. He was extradited illegally to Virginia (now West Virginia). On the night before he was executed he wrote a letter from prison stating that he was willing to die in the cause of liberty. The court decided to try him the next term, which began in February of 1860. He was hanged on March 16, 1860. (Courtesy of the Historic Photo Collection, Harpers Ferry National Historical Park.)

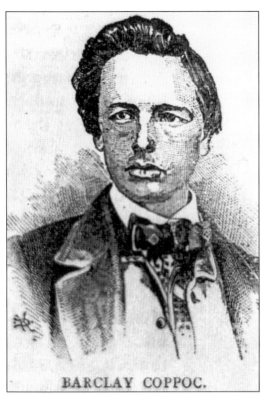

BARCLAY COPPOC.

BARCLAY COPPOC. Barclay Coppoc, only 20 years old and a Quaker, was living with his brother Edwin and mother in Springdale. She had begged him not to go to Harpers Ferry for the raid. He was designated a rear guard and, after the raid, escaped to Iowa where agents from Virginia attempted to arrest him. He eventually rejoined his mother. He enlisted in the Union Army, receiving his commission as first lieutenant on July 24, 1861. While serving in the Third Kansas Infantry a troop train fell while crossing a bridge over the Platte River and he was killed. Confederates had burned the supports away. He died September 3, 1861. (Courtesy of the Historic Photo Collection, Harpers Ferry National Historical Park.)

CHARLES PLUMMER TIDD. Charles Plummer Tidd was 25 and one of Brown's closest associates. Originally, he and Brown's own sons objected to the raid. As the raid began, Tidd and raider Cook headed into the woods to cut telegraph lines east and west of town. After the raid, he changed his name to Charles Plummer to avoid arrest. Later, he enlisted as a private then served as sergeant in the Twenty-First Massachusetts Volunteers. He died from fever on February 9, 1862, and is buried in the New Bern, North Carolina National Cemetery, in grave 40. (Courtesy of the Historic Photo Collection, Harpers Ferry National Historical Park.)

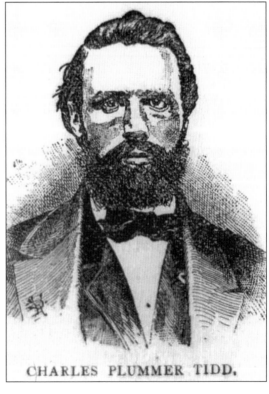

CHARLES PLUMMER TIDD.

FRANCIS JACKSON MERRIAM. Francis Jackson Merriam, from a Massachusetts abolitionist family, was rather frail with only one eye. In addition, he was either mentally challenged or emotionally unbalanced. He volunteered both his services and $600 in gold, which Brown took as a sign from God that his mission was blessed. The next night they began the raid. After the attack, he escaped, later enlisting in the Union Army. Early in the Civil War, he married Minerva Caldwell in Galena, Illinois. Merriam served as a captain in the Third South Carolina Colored Infantry and died suddenly in New York City on November 28, 1865. (Courtesy of the Historic Photo Collection, Harpers Ferry National Historical Park.)

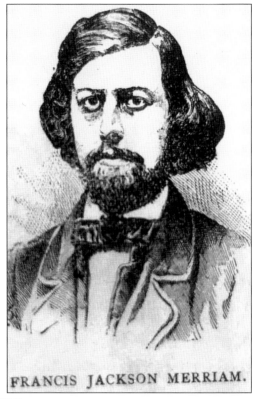

FRANCIS JACKSON MERRIAM.

OSBORN PERRY ANDERSON. African-American Osborn Perry Anderson, born free, was 30 during the raid. He met John Brown in Canada in 1858. He held the Arsenal with Hazlett while Brown gathered men into the engine house. He and Hazlett were able to escape and, because of the confusion and unruly crowds, they were able to paddle across the Potomac in a stolen boat. In 1864 he enlisted in the army, became a non-commissioned officer, and when the war ended was mustered out in Washington. He died of consumption December 13, 1872, Washington, D.C. (Courtesy of the Historic Photo Collection, Harpers Ferry National Historical Park.)

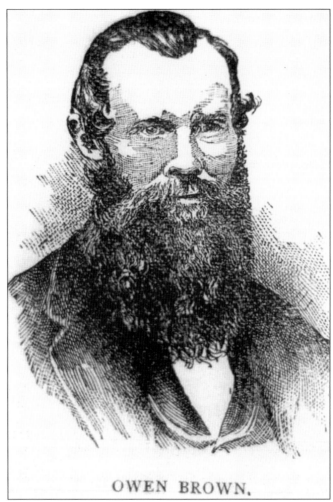

OWEN BROWN.

OWEN BROWN. Owen Brown, third son and named after John's father, had a crippled arm because of a childhood accident. He was detailed as a rear guard. At an appointed time, he was to move the pikes and guns to the schoolhouse to arm the slaves and whites that were expected to arrive. Of the five who escaped, Owen was the only one who never joined the Union Army. He settled in Ohio as a grape-grower. Eventually, he moved to California where he lived in a mountain home named "Brown's Peak." There, he died, January 9, 1891, at age 67. (Courtesy of the Historic Photo Collection, Harpers Ferry National Historical Park.)

Four

CIVIL WAR

If anything could destroy the spirit of Harpers Ferry, the Civil War very nearly did. However, the town was resilient and it did not succumb to what might have been its demise—it survives today as a reminder of its history and former glory.

After having changed hands eight times, the town was in shambles when the war ended. Both Union and Confederate troops had burned and ransacked the town each time they retreated, leaving it a shadow of its former self. The Union troops had burned both the Arsenal and the Armory while the Confederates troops had burned most of the factory buildings and blown up the railroad bridge. Both sides were guilty of helping to destroy the town.

Soldiers on both sides varied in age, with some as young as ten and some in their 40s. In addition, some women served, disguised as men of course. Also, The Emancipation Proclamation allowed black soldiers to fight for the Union if they chose to.

Medical care was primitive, with many dying on the battlefield. Even though wide-scale use of anesthetics for wounded was available, many died from wounds that today could easily be cured.

Residents were forced to flee the town, many never to return. Those who returned found the town in shambles, their property occupied by squatters. In addition, they were now residents of a new state, West Virginia. Sorting all of that out took patience and fortitude, qualities that Harpers Ferry residents needed then and need now, as the role of Harpers Ferry is ever changing.

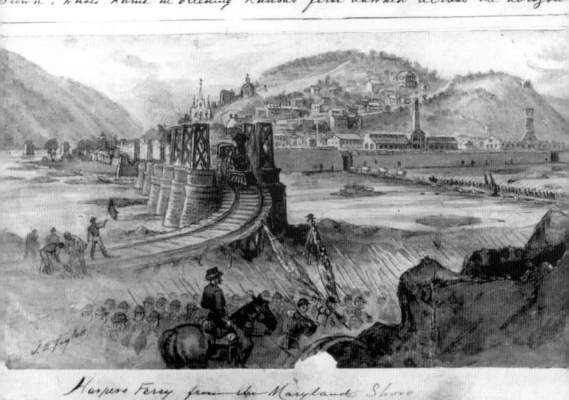

HARPERS FERRY FROM THE MARYLAND SHORE. This Civil War sketch of Harpers Ferry shows troops gathered on the Maryland shore. Soldiers can be seen on the train tracks with one trying to flag down an oncoming train. The Armory is still intact in this sketch. St. Peter's Catholic Church is visible as is St. John's Episcopal Church further up the hill. The bridge supports are visible across the Shenandoah River. (Courtesy of the Historic Photo Collection, Harpers Ferry National Historical Park.)

UNION SOLDIERS.
Taken close to 1861, this photo shows two Union soldiers who are members of the Twenty Second New York State Militia. They are standing in a full-length pose, holding their rifles, with the mountain in the background. It was probably taken on Camp Hill with either Maryland Heights or Loudoun Heights in the background. (Courtesy of the Library of Congress, Prints & Photographs Division, Digital ID: cph 3c19128.)

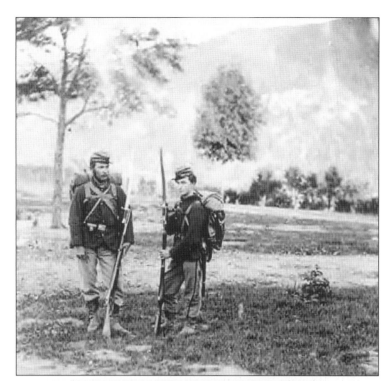

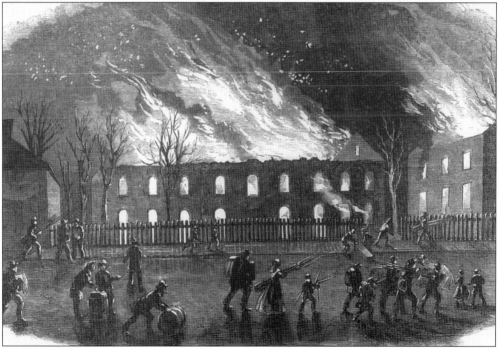

ARSENAL BURNS, 1861. At 10 p.m. on April 18, 1861, the U.S. Arsenal at Harpers Ferry burned. This was sketched from Shenandoah Street by D.H. Strother and reproduced from Harper's Pictorial History, volume 1, page 84. (Courtesy of the Historic Photo Collection, Harpers Ferry National Historical Park.)

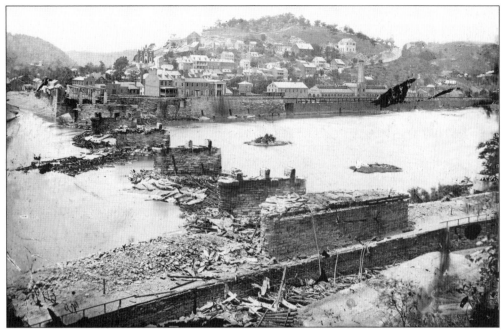

RAILROAD BRIDGE RUINS. This photo shows the ruins of the Baltimore and Ohio Railroad Viaduct. It was taken shortly after the bridge was destroyed. The Confederate forces destroyed it on June 14, 1861. During the Civil War, this bridge was destroyed and replaced nine times between June 1861 and April 1865 and Mr. Thomas N. Heskett was superintendent of construction every time. No accidents could ever be traced to any defect in the bridge itself or on its track. This photo was taken from beneath Maryland Heights. The Potomac River flows from the right, and the Shenandoah flows just to the left of the town (out of the picture). The two rivers come together just to the left of this photograph. (Courtesy of the Library of Congress, American Memory, Digital ID: cwpb 04106.)

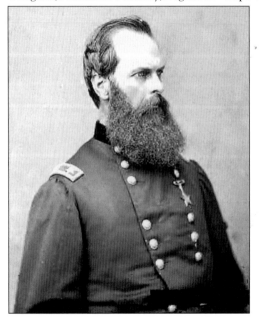

MAJ. GEN. JOHN W. GEARY. Major Geary, pictured sometime between 1860 and 1865, was an officer in the Federal Army. He posted advertisements recruiting soldiers for his command in Harpers Ferry. This photo was taken by Brady National Photographic Art Gallery (Washington, D.C.). (Courtesy of the Library of Congress, Prints & Photographs Division, Digital ID: cwpb 06117.)

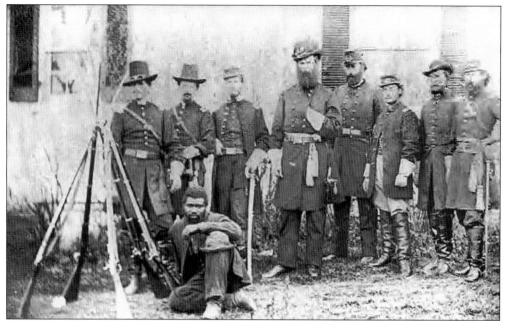

JOHN WHITE GEARY. John White Geary, center of photo with beard and left arm inside his shirt, poses with his staff at Harpers Ferry. A black man sits in front of the group, beside a tent of rifles. On September 17, 1861, Col. John W. Geary of the Twenty Eighth Pennsylvania Volunteers and a company of the Thirteenth Massachusetts retook Harpers Ferry. He then withdrew from the town on October 18, 1861, after a skirmish on Bolivar Heights. (Courtesy of the Library of Congress LC-USZ62-65083.)

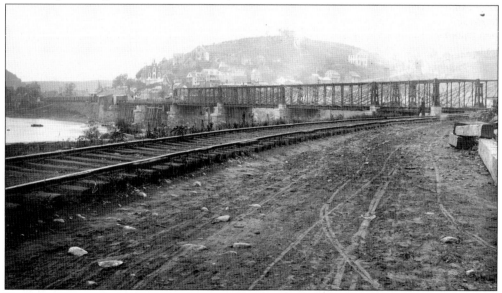

HARPERS FERRY, SEPTEMBER OR OCTOBER, 1862. This photo was taken before the railroad bridge was destroyed during a Civil War battle. After the battle was over, the bridge was in ruins. This photo was taken sometime between September and October of 1862. During the Civil War, the town of Harpers Ferry changed hands eight times and after the war, the town was in shambles. (Courtesy of the Library of Congress, Digital ID: cwpb 03739.)

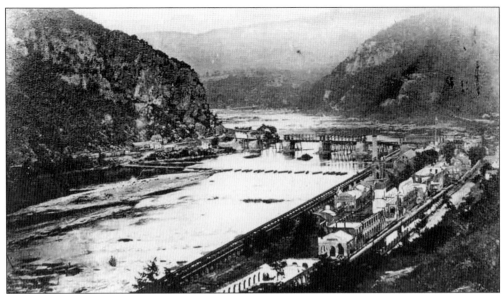

MUSKET FACTORY RUINS. Brady, a well-known Civil War photographer, took this from Magazine Hill in 1862. It was published as a drawing in *Harper's Weekly* on October 4, 1862, on page 268. This photo shows an excellent view of the Musket Factory and the damaged railroad bridge. Also visible is a pontoon bridge that crossed the Potomac River, along with parts of the cliffs of Maryland Heights on the left, and Loudoun Heights on the right. Both Maryland and Loudon Heights had much less vegetation than they have today. The river on the left is the Potomac, which joins with the Shenandoah that comes down from the right (out of the picture). (Courtesy of the Historic Photo Collection, Harpers Ferry National Historical Park.)

RUINS OF ARSENAL. Silas A. Holmes took this photograph of the ruins of the Arsenal in October of 1862. In the background, on the left, is Maryland Heights. Loudoun Heights is visible on the right, in the background. The rivers are not visible but are just beyond the ruins. The men seem to be contemplating the future of Harpers Ferry, if indeed there would be a future for the town, or possibly, what it had been like in days gone by. This photo was taken close to the Musket Factory Building No. 18, at the west end in October 1862. (Courtesy of the Library of Congress, American Memory Collection, Digital ID: cwp 4a39558.)

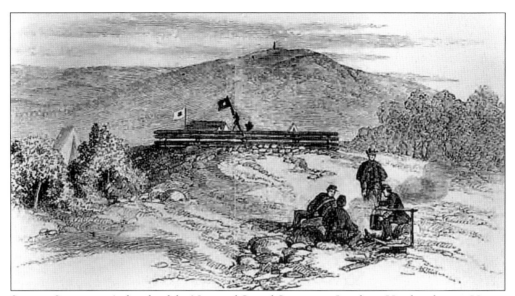

SIGNAL STATION. A sketch of the National Signal Station on Loudoun Heights shows a Union signal station and encampment. The men are communicating with a station on Maryland Heights, just across the river. The members of the signal corps communicated with other corps members using flags, torches, and lights as they employed three different motions to create their messages. In addition to warning of impending danger, they intercepted and translated enemy messages, as well as using the stations as observation posts. This drawing appeared in *Harper's Weekly, c.* November 1862. (Courtesy of the Historic Photo Collection, Harpers Ferry National Historical Park.)

TWENTY SECOND NEW YORK STATE MILITIA. Pictured here in 1862 is a soldier from the Twenty Second New York State Militia. He was stationed near Harpers Ferry, probably on Camp Hill. He stands in front of a cannon on Camp Hill while displaying his rifle. (Courtesy of the Historic Photo Collection, Harpers Ferry National Historical Park.)

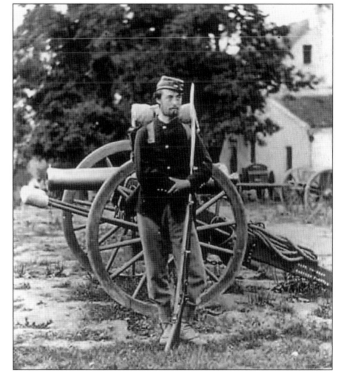

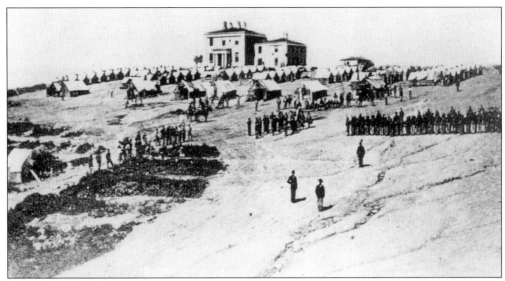

CAMP HILL, FEDERAL HILL, 1862. This view shows the Federal Camp on Bolivar Heights, actually Camp Hill. It is an excellent view of the Armory Dwelling House, the commanding officer's or Armory superintendent's House. This whole area was part of Virginia at that time. Troops can be seen practicing drills. (Courtesy of the Historic Photo Collection, Harpers Ferry National Historical Park.)

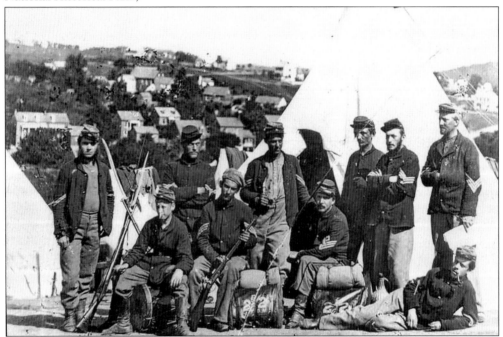

NCO's, COMPANY E, TWENTY SECOND NEW YORK STATE MILITIA. This photo was taken October 1862 on the western edge of Camp Hill in Bolivar. Houses in Bolivar can be seen in the distance. These soldiers are all members of the Twenty Second New York State Militia. The man in the left front is sitting on the drum that they took into battle. Some of their weapons can be seen to his right. (Courtesy of the Historic Photo Collection, Harpers Ferry National Historical Park.)

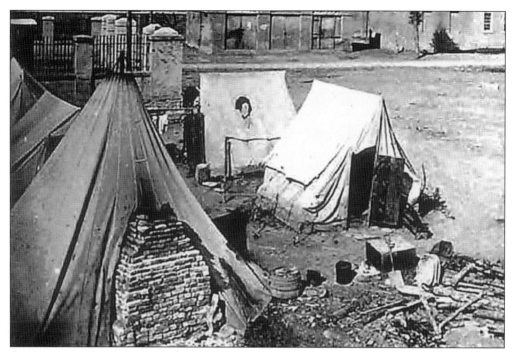

CONTRABAND CAMPS. During the Civil War, free or escaped slaves were housed in Contraband Camps that were established by Federal forces. Here the camp is located inside the former Musket Factory yard on the former Armory Grounds. In the background, a portion of John Brown's Fort can be seen, still in its original location. (Courtesy of the Historic Photo Collection, Harpers Ferry National Historical Park.)

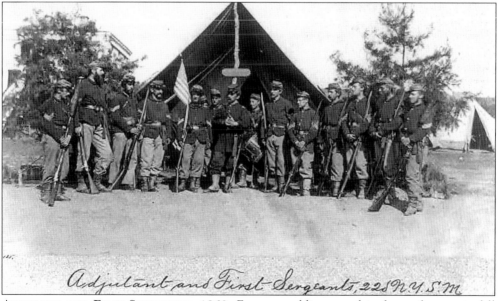

ADJUTANT AND FIRST-SERGEANTS, 1862. Fourteen soldiers posed in front of a tent in full uniform beside their rifles, displaying the Union flag. The Adjutant and First-Sergeants were members of the Twenty Second New York State Militia. (Courtesy of the Library of Congress, Prints & Photographs Division, Digital ID: cph 3b36999.)

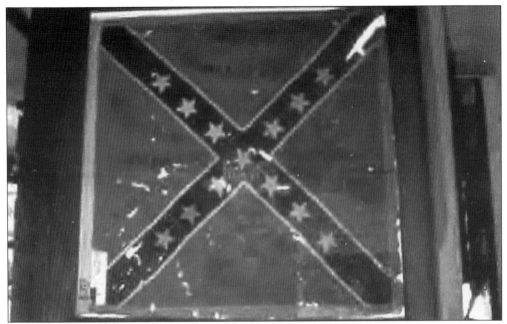

BATTLE FLAG OF THE FORTY-EIGHTH MISSISSIPPI INFANTRY REGIMENT. Regiments carried their flags into battle with them. After the battles, they would put the name of that battle on the flag somewhere. This flag was the Battle Flag of the Forty Eighth Mississippi Infantry Regiment. On the back the following battle names were found: Yorktown, Williamsburg, Seven Pines, Beaver Dam, Gaines Mill, Frazier's Farm, 2nd Manassas, Sharpsburg, Harpers Ferry, Bristow Station, Gettysburg, Fredericksburg, Chancellorsville and Deer Run. (Courtesy of the CivilWarAlbum.com, photo by Mike O'Neal, www.civilwaralbum.com.)

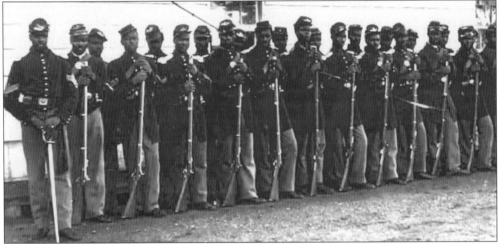

COMPANY E, FOURTH UNITED STATES COLORED INFANTRY. As the Civil War began, many African Americans tried to serve in the Union army but were turned away. At that time, President Lincoln was afraid of the reception they would receive, as many servicemen were offended at having to serve with or alongside African Americans. After the Emancipation Proclamation of January 1, 1863, recruitment became legal and many men served in all-black units, headed by white officers (segregation was still in place). This unit guarded the nation's capital. (Courtesy of the Library of Congress, Historical Documents.)

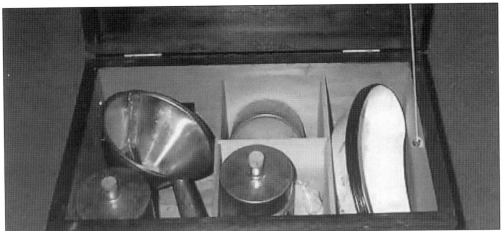

CONFEDERATE ANESTHESIA SET. Several forms of anesthesia and painkillers were available for medical professionals during the Civil War. Among them were the following: chloroform, ether, opium, or derivatives of opium, laudanum, and morphine. Ether and chloroform were the drugs of choice. When the preferred drugs were not available, botanical substitutes were used. Very often, the soldiers were given opium, to which they became addicted. Fortunately, opium was available at local drugstores. Prior to the Civil War, approximately 90 percent of American "surgeons" had only performed minor surgeries. During the Civil War some 80,000 amputations were performed, most done with general anesthesia. (Photo courtesy of the http://home.nc.rr.com/fieldhospcsa/Anesthesia.html.)

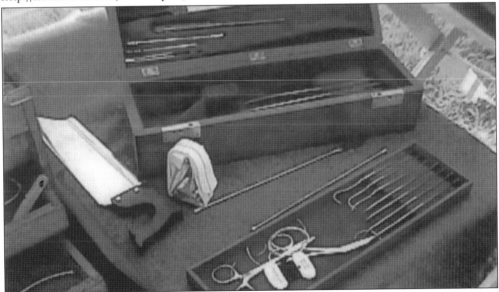

AMPUTATING INSTRUMENTS. This photograph shows the standard surgical instruments used during the Civil War. The saw on the left (shaped like a meat cleaver) was used to cut through long bones such as tibia, fibula, radius, ulna, femur, and humerus. Fingers and toes were amputated with the smaller saws. Bullets were located using the long, porcelain tipped probes. The surgeon could differentiate between the sounds made by tapping the probes against bones or lead. In addition, the white tip of the probe when rubbed against the lead bullet would show gray color. Ed Archer and Son, of Knoxville, Tennessee made this set. (Photo courtesy of the http://home/mc/rr.com/fieldhospcsa/Amputating.html.)

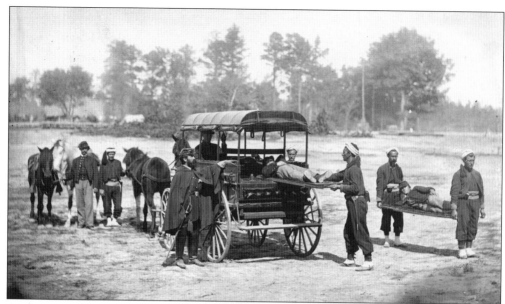

AMBULANCE REMOVES BODIES. Here an ambulance crew demonstrates the removal of wounded soldiers from the battlefield. This ambulance has four wheels, which made the ride less bumpy. The ambulances with only two wheels were so bumpy that wounded often died before they could get adequate medical attention. This crew is part of a Zouave unit that prided itself on precision drill, volunteers who were morally upright, wore flamboyant uniforms, and were better known than the French Foreign Legion in their day. Their origins can be traced back to a tribe in Algeria and Morocco. (Courtesy of the Library of Congress, American Memory Collection, Digital ID: cwpb 04095.)

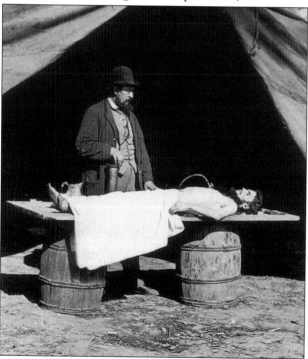

CIVIL WAR EMBALMING. Here a surgeon prepares to embalm a soldier's body; neither is identified. Some surgeons and pharmacists became embalmers during the war. As such, they would follow the troops and were able to prepare bodies for shipment home for fees up to $100. There were between 10,000 and 40,000 men embalmed, most were officers. The embalmers knew that the officer's families would probably pay the fee. Railroads would only accept bodies that were embalmed, disinfected, or sealed in airtight cases. These bodies would then be odorless and the railroad would ship them home. (Courtesy of the Library of Congress, American Memory Collection.)

SHERIDAN'S HEADQUARTERS. This is a sketch of Sheridan's Headquarters in Harpers Ferry during the Civil War in 1864. It was sketched by James E. Taylor and appeared in Frank Leslie's *Illustrated Newspaper*, September 3, 1864, on page 381. Sheridan's Headquarters is also known as the Lockwood House. The building was built in 1847 and served as the quarters for the Armory Paymaster. In 1867, it became the birthplace of Storer College, a normal school established for men and women regardless of race, sex, or religion. (Courtesy of the Historic Photo Collection, Harpers Ferry National Historical Park.)

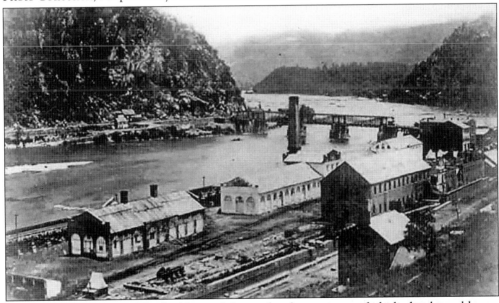

SHERIDAN'S CAMPAIGN. The buildings of the musket factory were refurbished to be usable as a quartermaster depot for Union forces. This was in 1864 during Maj. Gen. Philip Sheridan's Shenandoah Valley Campaign. The damaged portion of the southern span of the Potomac Railroad Bridge can be seen. (Courtesy of the Historic Photo Collection, Harpers Ferry National Historical Park.)

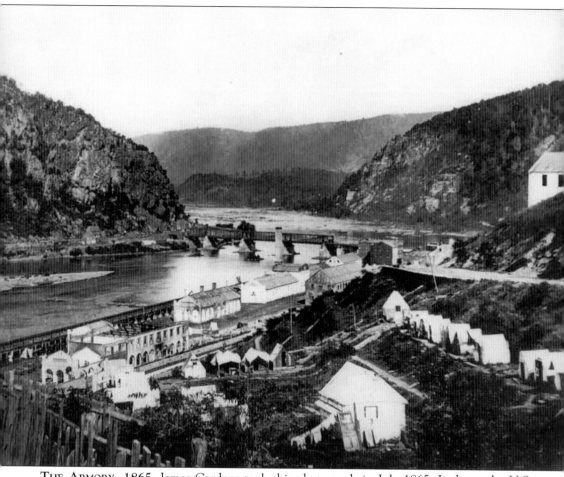

THE ARMORY, 1865. James Gardner took this photograph in July 1865. It shows the U.S. Musket factory from Magazine Hill. Maryland Heights is across the Potomac River on the left and Loudoun Heights is across the Potomac River on the right. In the center of the picture, the Potomac Railroad Bridge is shown. A tent camp can be seen in the right foreground. Also identifiable is a new hotel on the Ferry Lot, a Methodist Protestant church, and Musket Factory Buildings No. 8C, 8B, 8A, 3, 12, 13, 14, as well as the C&O Canal. (Courtesy of the Historic Photo Collection, Harpers Ferry National Historical Park.)

Five

VIRGINIUS ISLAND AND INDUSTRIES

Consisting of approximately 11 acres, Virginius Island is the last island in the Shenandoah before it merges with the Potomac at Harpers Ferry. It was once an enticing site for 19th-century industrial development, which relied on the waterpower available as the river fell 14 feet per mile. Once a bustling and thriving island, housing many and varied industries, it boasted a flour mill, sawmill, iron foundry, tannery, machine shop, cotton mill, cooperage, and carriage shop.

When the water level was low it was one large island, when the level was higher it consisted of several smaller islands, and the island disappeared completely when the river flooded. The Federal Armory at Harpers Ferry stimulated development of the island. For a time, the Winchester and Potomac Railroad was granted a right of way for its track on the island and even built a depot, which stood until the late 1840s, when it finally built one in Harpers Ferry. Ownership of the island changed hands periodically and it became legally part of Harpers Ferry when the Virginia General Assembly incorporated the town in the early 1850s.

Before the Civil War, as many as 180 people lived on the island. Many of them were employed on the island. During the Civil War, the island was used as stables, barracks, workshops, corrals, a hospital, or for storage purposes.

As the nation made the conversion from waterpower to steam, small villages, such as Virginius Island, declined in size and number. Floods caused damage repeatedly, and in 1936, the worst recorded flood forced the last of the residents out. Nature gradually reclaimed the island as sycamores, maples, and other vegetation took over and it became much like it is today.

Today, wetlands fill the old abandoned canals and Virginius Island is hardly recognizable as the once thriving industrial complex that it was.

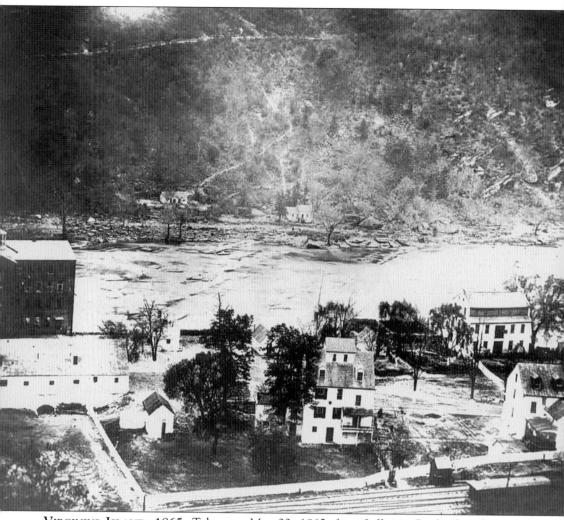

VIRGINIUS ISLAND, 1865. Taken on May 22, 1865, from Jefferson Rock, this photograph shows Loudoun Heights in the background, across the river. In the foreground, the large dark building on the left is the cotton mill, later converted to a flour mill. Directly in front of that is the gas house (gas was used to run the looms), a long light-colored building. In the foreground to the far right is the house of John Smith, a machinist who was English. A machinist was once called a millwright. Behind that is the Hood House where the cooper had his cooper shop. (Courtesy of the Historic Photo Collection, Harpers Ferry National Historical Park.)

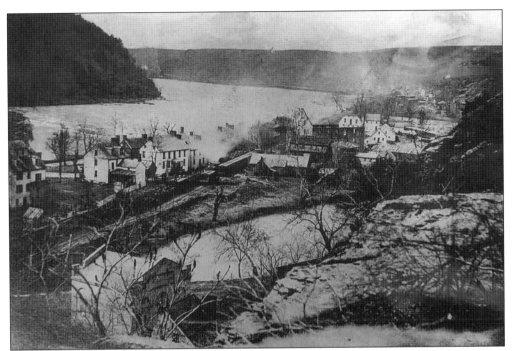

VIRGINIUS ISLAND, 1865. This view of the upper part of Virginius Island was taken on May 22, 1865, from Jefferson Rock. Loudoun Heights is on the left with a good view of the Shenandoah River. The W&P Railroad can be seen with a train on the tracks beside the Shenandoah Canal. Union troops can be seen on the train. The Hall Rifle Factory is partly visible in the distance. Also visible are the Armory Stables. (Courtesy of the Historic Photo Collection, Harpers Ferry National Historical Park.)

RUINS, ARMORY SMITH, AND FORGING SHOP. Taken in 1869, this photograph shows the ruins of the Armory Smith and Forging Shop. In the foreground, you can see a 15-foot overshot wooden water wheel. Just as waterpower was the main source of power for many of the industries on Virginius Island and other towns during this time, water would also be the undoing of Virginius Island. (Courtesy of the Historic Photo Collection, Harpers Ferry National Historical Park.)

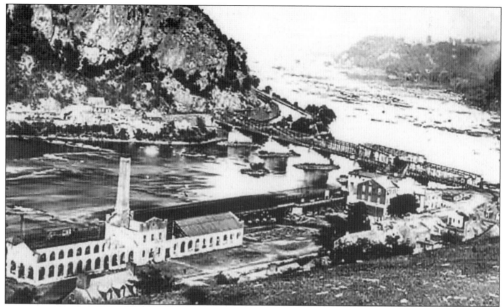

RUINS, 1870. This photograph of the ruins of the Armory Smith and Forging Shop was taken in 1870. The Bollman Bridge, across the Potomac, was completed, only to be destroyed later by the flood of 1936. Maryland Heights is to the left, with sparse vegetation. The C&O Canal can be seen center at the foot of Maryland Heights. The water level of the rivers seemed to be rather low when this photograph was taken, as evidenced by the number of rocks visible. (Courtesy of the Historic Photo Collection, Harpers Ferry National Historical Park.)

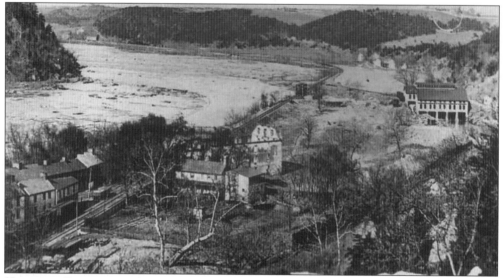

VIRGINIUS ISLAND AND SAVERY MILL, C. 1885–1936 OR 1888. Taken from Jefferson Rock, this view shows Herr Mill ruins and other houses on the island. The Confederates had burned Herr's Mill in October 1861. In the distance is Lake Quigley behind the Shenandoah Pulp Company mill. A local resident said that after the flood of 1936, the houses along the street were torn down and the stones used to repair the Potomac River Dam. In the lower left side of the photo a pile of railroad cross ties can be seen. (Courtesy of the Historic Photo Collection, Harpers Ferry National Historical Park.)

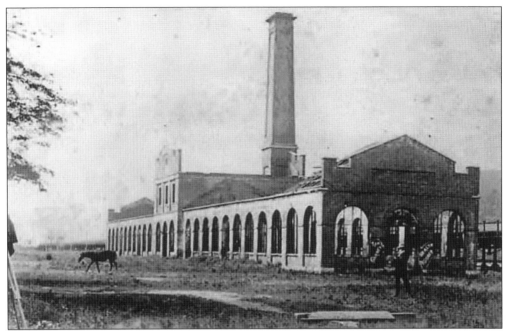

ARMORY SMITH AND FORGING SHOP. This photograph is of the ruins of the largest armory building, the Armory Smith and Forging Shop, and was taken during a photography session on May 29, 1886. After the flood of 1889, the workshop was torn down. There is a man standing nearby, a building, and a horse walking on the left side of the picture. The smokestack is 90 feet tall. There were signs painted on the east end of the building. There is a railroad trestle in the background. (Courtesy of the Historic Photo Collection, Harpers Ferry National Historical Park.)

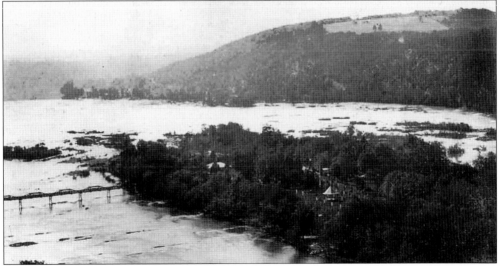

ISLAND PARK, 1886. This photograph was taken on May 29, 1886, and shows the Potomac River and the Island Park Amusement area. It also shows a clear view of the bridge to the mainland. The amusement park on the island was provided by the Baltimore and Ohio Railroad as entertainment. (Courtesy of the Historic Photo Collection, Harpers Ferry National Historical Park.)

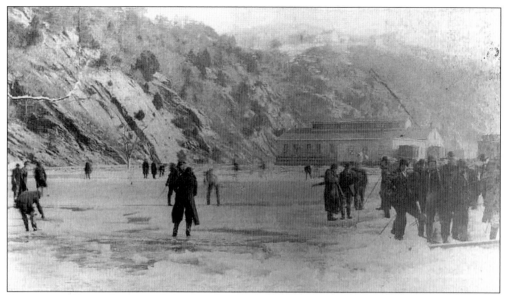

SKATING ON LAKE QUIGLEY. Lake Quigley was located behind the Shenandoah Pulp Company and adjacent to Virginius Island. The Shenandoah Pulp Company used water-powered machinery, as did many industries. Shenandoah Pulp Company made wood pulp, which was a raw material for the production of paper. This photograph shows a group of people enjoying winter activities on Lake Quigley. The photograph dates from either 1893 or 1910 (according to two sources). (Courtesy of the Historic Photo Collection, Harpers Ferry National Historical Park.)

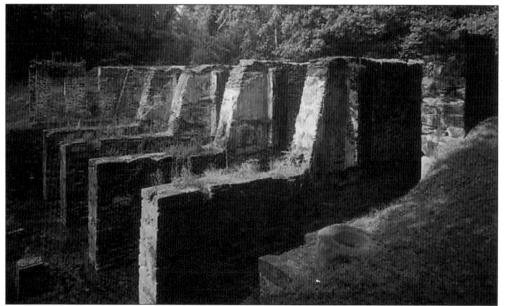

SHENANDOAH PULP MILL. This is a photograph of the ruins of the Shenandoah Pulp Mill on Shenandoah Street in Harpers Ferry. When visitors come to Harpers Ferry National Historic Park today, they first go to the Cavalier Heights visitor center and catch shuttle buses, which bring them into the Lower Town. As the bus travels down into the Lower Town, these ruins are visible on the right. (Courtesy of the Library of Congress, HAER, WVA, 19-HARF, 31-2.)

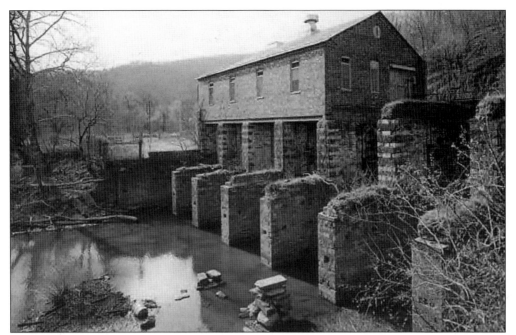

POWER PLANT, WEST VIRGINIA SHORE. This is a photograph of the Power Plant on the West Virginia Shore of the Potomac River at Harpers Ferry that can be seen when looking southeast. It was located about one mile from the confluence of the Shenandoah and the Potomac, at the end of Potomac Street. It was originally built in 1888, and was partially rebuilt and reconfigured in 1925. It was an innovative, small hydroelectric plant that operated from 1899 to 1991. It occupies the former site of the Harpers Ferry National Armory Building. (Courtesy of the Library of Congress, HAER, WVA, 19-HARF, 30-2.)

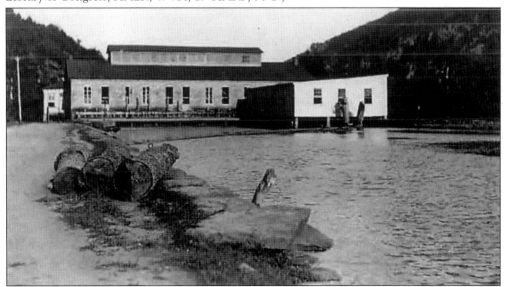

LAKE QUIGLEY. This is a view of Lake Quigley and the rear of the Shenandoah Pulp Company mill. The mill opened in 1888 and produced spruce ground wood pulp. The wood pulp was a raw material needed to make paper. The logs in the foreground might have been used for that purpose. (Courtesy of Historic Photo Collection, Harpers Ferry National Historical Park.)

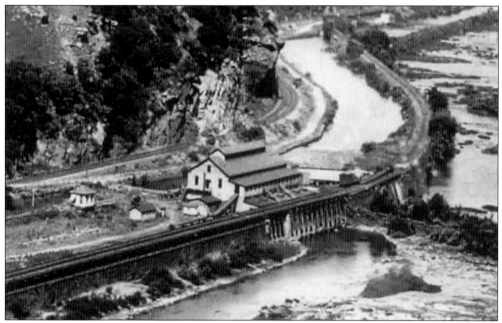

PAPER COMPANY, C. 1900. This photograph shows the Upper Potomac River from Maryland Heights. The Harpers Ferry Paper Company can be seen. Behind it is the Armory Canal. Afloat on the canal are the pulpwood logs that await processing into ground wood pulp. Railroad tracks can be seen running between the canal and the Shenandoah River. On the left is a portion of Camp Hill. (Courtesy of the Historic Photo Collection, Harpers Ferry National Historical Park.)

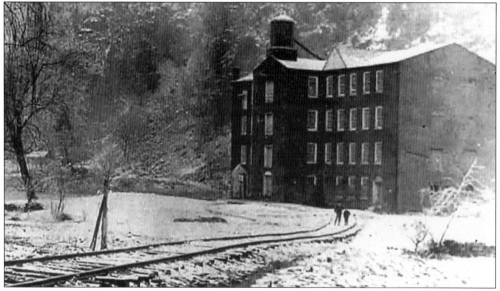

COTTON FACTORY. This photograph of the Cotton Factory building was taken sometime between 1890 and 1913. From 1867 to 1889 the building served as the Child and McCreight Flour Mill. The railroad spur track that is in the foreground was built in 1869. Two people can be seen on the railroad tracks. (Courtesy of the Historic Photo Collection, Harpers Ferry National Historical Park.)

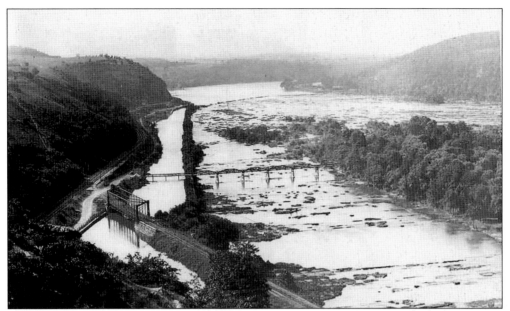

ISLAND PARK, 1906. This photograph shows a good view of the Potomac in 1906. It shows a good view of Island Park and the crossing bridge to the mainland. Also visible are the United States Canal and the Baltimore and Ohio Railroad tracks. This photograph was taken from Maryland Heights, looking northeast along the Potomac. (Courtesy of the Historic Photo Collection, Harpers Ferry National Historical Park.)

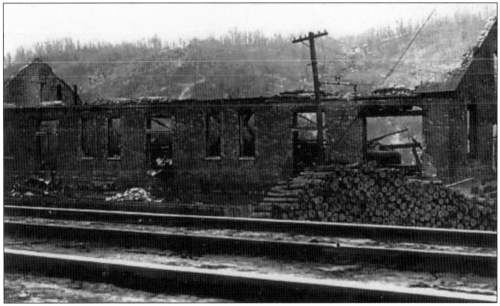

SAVERY MILL RUINS ON POTOMAC RIVER. This photograph shows the charred remains of the paper company. On January 15, 1925, a fire destroyed this building of the Harpers Ferry Paper Company. The Potomac Power Plant would later be erected on this site and the standing walls in this photo were incorporated into that structure. Maryland Heights, sparsely covered with vegetation, can be seen in the background. (Courtesy of the Historic Photo Collection, Harpers Ferry National Historical Park.)

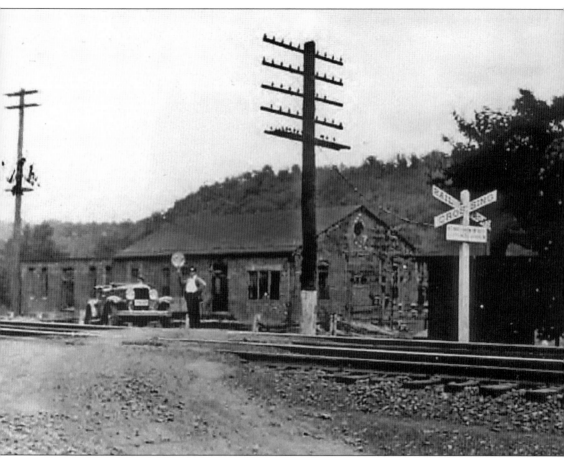

POTOMAC POWER PLANT, C. 1922–1930. A crossing guard at the railroad tracks in front of the Potomac Power Plant in the 1930s is visible in this photograph. This power plant was an innovative hydroelectric station built on the foundations of the Harpers Ferry Paper Company. The Harpers Ferry Paper Company burned in 1925. (Courtesy of the Historic Photo Collection, Harpers Ferry National Historical Park.)

Six

TOWN AND
HISTORIC BUILDINGS

Harpers Ferry made history for several reasons and various notable people. George Washington and his Armory and Arsenal, Robert Harper and his ferry, Thomas Jefferson and his eloquent description, John Brown and his Raid, and the Civil War and its traumas all contributed to its story.

Today it stands as tribute to all of them. The town survived! Wisely preserved by the National Park Service and revered by all who come to visit or study, it serves as a quiet respite from the busy world. As we step onto the well-preserved streets and into the refurbished houses and buildings, we can catch a glimpse of what life was like in days of yore. We should take our time to meander the streets and ponder how unhurried life was in years gone by. In addition, as we take our pictures, we can only hope to catch a glimpse in our photographs of what Harpers Ferry really stands for.

Photographs in this chapter are arranged chronologically when possible. They come from various sources, as noted in the credit lines. Especially important are the photos taken by the Library of Congress. The Library of Congress and the National Park Service are examples of our tax dollars well spent, preserving and protecting our past for future generations.

ARMORY AND ARSENAL IN 1861. President George Washington requested and approved two arsenals, one in Springfield, Massachusetts, and one in Harpers Ferry. After purchasing the land from Robert Harper, the government built the Armory to make weapons and the Arsenal to store them. Many weapons used in the war of 1812 were manufactured in the Harpers Ferry facility. Because of frequent floods, weapons were sometimes stored higher up in the town, as was the case when John Brown led his raid on the Armory and Arsenal. This photograph was published in *Harper's Weekly* months before the Raid. The tower, a stone crenellated bell tower, was erected between 1860 and 1861. To the right of the tower was a workshop for files and cutting and milling machines. (Courtesy of the Historic Photo Collection, Harpers Ferry National Historical Park.)

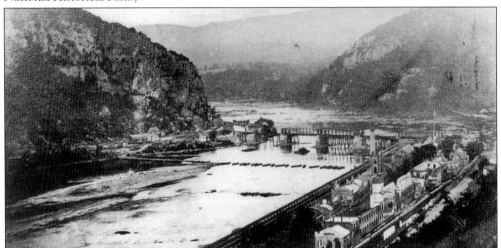

U.S. RIFLE FACTORY ON HALL'S ISLAND, 1865. Taken from near Jefferson Rock, this shows the massive ruins of nine buildings of the Rifle Factory. Also visible are South Bolivar, the Potomac River on the left and the Shenandoah River to the right in the middle of the picture. On the left is Maryland Heights and across the rivers (after they join) is Loudoun Heights. It was on top of Loudoun Heights that the Signal Corps was located. Homes visible on the right are in South Bolivar. (Courtesy of the Historic Photo Collection, Harpers Ferry National Historical Park.)

PRESBYTERIAN CHURCH, 1865. This is an interesting photograph because it shows the Presbyterian church as well as people standing on Jefferson Rock in the distance. The photograph was taken in 1865 and was included in a stereopticon view. The photographers were Bell and Brothers, Pennsylvania Avenue, Washington, D.C. This was part of the Henry T. McDonald Collection. (Courtesy of the Historic Photo Collection, Harpers Ferry National Historical Park.)

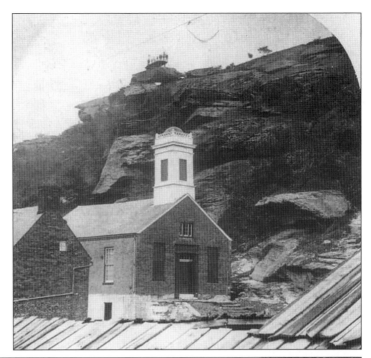

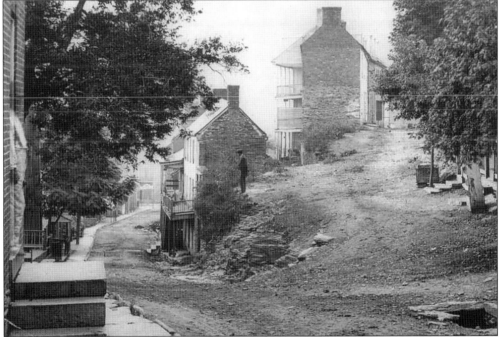

HIGH STREET, 1873. This photograph, taken in 1873, shows the upper end of the Six-Acre Reservation, as the original tract was known. The photograph shows the topography of the intersection of Marmion Row (Public Walk) on the right and High Street on the left. At this point, neither High Street nor Marmion Row had any paving whatsoever. Compare this photograph with the one found on page 124. (Courtesy of the Historic Photo Collection, Harpers Ferry National Historical Park.)

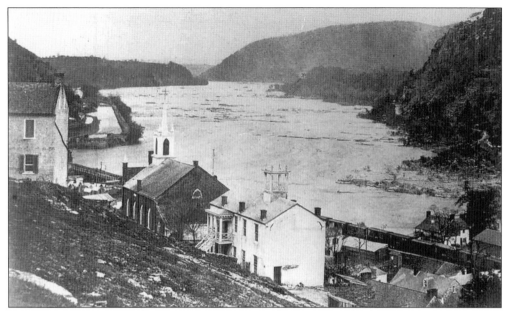

OLD CATHOLIC CHURCH AND SCHOOLHOUSE. This photograph shows a view of the area behind the Catholic church and schoolhouse. It also shows portions of the Shenandoah River just before the Bollman Bridge was completed in 1870. A portion of the C&O Canal is visible on the left. A train is traveling through town on the right. Rooftops on Shenandoah Street are visible. Across the river on the right is Loudoun Heights where a dirt road can be seen. (Courtesy of the Historic Photo Collection, Harpers Ferry National Historical Park.)

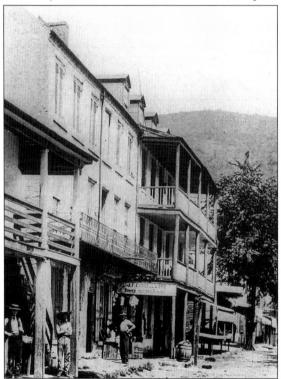

SHENANDOAH STREET, 1882–1889. This photograph shows the stores along Shenandoah Street, along with several men standing on the sidewalks. The store in the center of the photograph sells stoves and the sign appears to read, "J. F. Cassell Bros." Notice the still unpaved roads. Maryland Heights is visible in the background. (Courtesy of the Historic Photo Collection, Harpers Ferry National Historical Park.)

BURTON'S JEWELRY STORE. Taken between 1882 and 1889, this image shows Howard Burton, son of Alfred Burton, standing in the left side of the open doorway. The other two men—in the window and in the right side of the doorway—are unidentified. This store was located a few doors up on the right side of High Street, in what is now classified as Building 14. (Courtesy of the Historic Photo Collection, Harpers Ferry National Historical Park.)

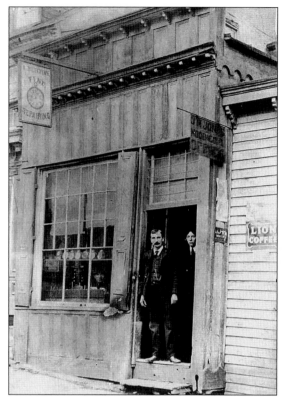

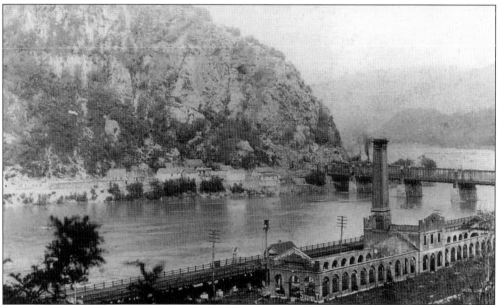

RUINS, 1886. The ruins of the largest armory buildings are pictured May 29, 1886. Seven buildings can be seen on the north bank of the Potomac River. The iron railroad bridge that goes from The Point to Maryland Heights is still intact. Maryland Heights is clearly seen with sparse vegetation. (Courtesy of the Historic Photo Collection, Harpers Ferry National Historical Park.)

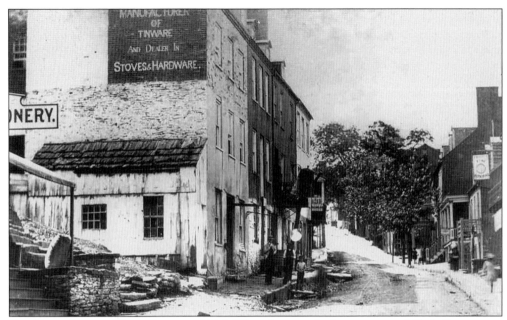

THE LEFT SIDE OF HIGH STREET, 1886. This photograph shows unpaved High Street as it appeared on May 29, 1886, taken from the south end of the street. The four buildings on the left near the stone steps were later destroyed. Notice the advertisement on the side of the building: "Manufacturer of Tinware and Dealer in Stoves & Hardware." Above the sidewalk in front of the store is a sign shaped like a large coffee pot, and below that a very large cooking pan. The boy in the street is wearing no shirt. (Courtesy of the Historic Photo Collection, Harpers Ferry National Historical Park.)

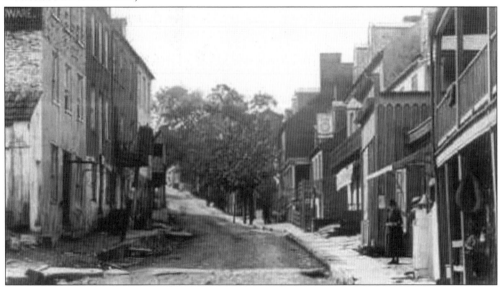

RIGHT SIDE OF HIGH STREET, 1886. Taken on May 29, 1886, here is unpaved High Street from the Lower Town, looking up. Notice the harness hanging on a hook on the post to the right of the building. Notice the bell on the right just after the harness—they probably used that instead of telephones. A woman stands on the wooden sidewalk. (Courtesy of the Historic Photo Collection, Harpers Ferry National Historical Park.)

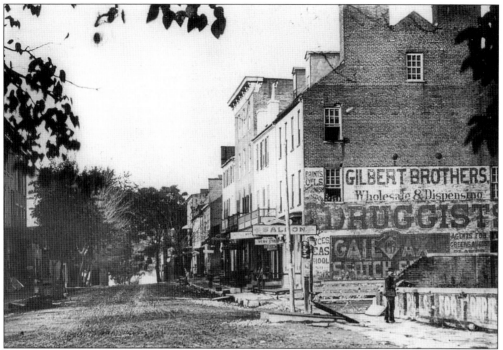

GILBERT BROTHERS. The Gilbert Brothers were only in business from 1886 to 1889. This photo, *c.* 1890, shows the north side of Shenandoah Street, looking toward the west end of the street. A man can be seen standing near the remains of the Armory wall. Wagon tracks can be seen in the dirt of the street. (Courtesy of the Historic Photo Collection, Harpers Ferry National Historical Park.)

1890 RUINS OF ARMORY. In this 1890 photograph, the ruins of the Harpers Ferry Armory are clearly seen. The Armory gates are still in place. John Brown's Fort is in its original location. The chimneystack on the right is the only remaining portion of the Smith and Forging Shop still standing. At the far end of the old Armory yard, you can see the Paper Company mill. (Courtesy of the Historic Photo Collection, Harpers Ferry National Historical Park.)

DORAN'S STORE, LATE 1890S. Doran's Store was located on the south side of Shenandoah Street in the business section of Harpers Ferry. Presumably, the man is the proprietor of the store. Notice the goods displayed out in the open that must be brought in every night. The places of business were on the ground floor and the upper floors were used as residences. Doran's Store occupied what is now buildings 34 and 35 of the National Park at Harpers Ferry. (Courtesy of the Historic Photo Collection, Harpers Ferry National Historical Park.)

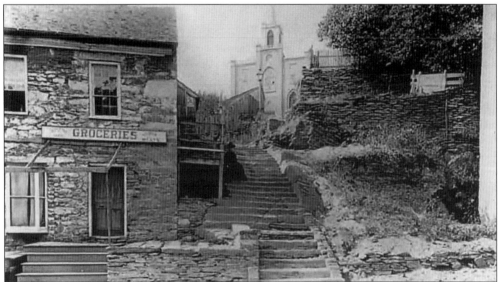

ST. PETER'S CATHOLIC CHURCH AND THE STONE STEPS. A lady rests on the Stone Steps *c.* 1888–1892. This photograph was taken by W.C. Russell and shows the stone steps leading up to St. Peter's Catholic Church on the hill. The building in the foreground on the left is being used as a grocery store, as evidenced by the "Groceries" sign on the side of the stone wall. Renovation of St. Peter's Church would not begin until 1896. (Courtesy of the Historic Photo Collection, Harpers Ferry National Historical Park.)

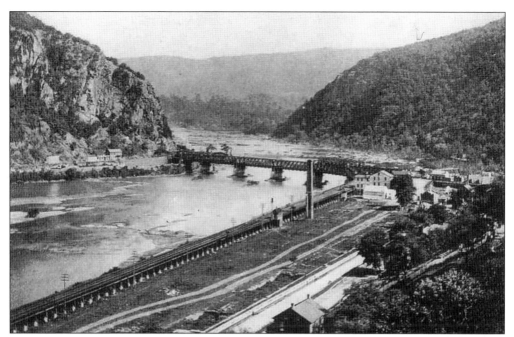

ARMORY, 1890–1891. Shown here is the Armory yards after the buildings had been removed. This shows Harpers Ferry from Magazine Hill. The view of the junction of the two rivers is clearly seen, with only one span of the Shenandoah Bridge in place after the 1889 flood. Only the chimney of the Musket Factory Smith shop is still standing. The Engine house is still standing but the Armory Office building has been destroyed. The Armory Canal, C&O Canal, Maryland Heights, on the left, and Loudoun Heights, on the right, are visible. (Courtesy of the Library of Congress, W.C. Russell photo from Thomas Featherstonhaugh Collection.)

JEFFERSON ROCK, LATE 1800S OR 1900. Ten people pose in a group photograph at Jefferson Rock with Loudoun Heights in the background. People in the photograph are, from left to right, as follows: (front row) Mrs. Marsha Elizabeth Evans, Mrs. Maggie Lovett Daniel, unidentified, unidentified, Charles E. Jones, Mrs. Etta Lovett Hill, Mrs. Florence Lovett Canty, and unidentified; (back row) Allen P. Daniel and John H. Hill. The attire of suits for the gentlemen and dresses for the ladies, with hats for all, was common daily wear. (Courtesy of Historic Photo Collection, Harpers Ferry National Historical Park.)

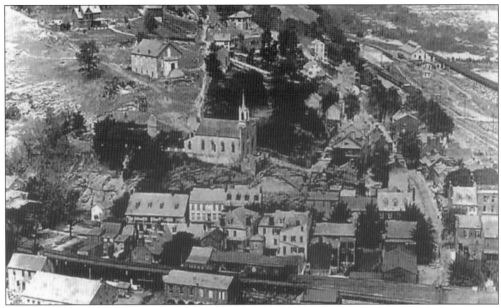

HARPERS FERRY C. 1895. St. Peter's Catholic Church is located in the center of this photograph, which was taken from across the Shenandoah River on Loudoun Heights. St. Peter's is easily identifiable with its white steeple. To the left and behind St. Peter's is St. John's Episcopal Church that stands in ruins today. It was damaged heavily during the Civil War, rebuilt in 1882, and sold in 1895 due to declining membership. The Armory Market Building, the two-story building with the arches on the lower floor, is visible in this photograph on the bottom center. At the top of the photograph is the Hilltop Hotel, started in 1888, and is still in use today as a hotel. This was probably taken in 1895, before the renovation of the St. Peter's Church in 1896. (Courtesy of the Historic Photo Collection, Harpers Ferry National Historical Park.)

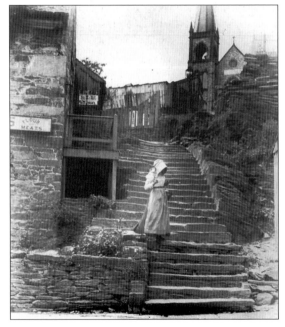

GIRL DESCENDS STONE STEPS. This clear photo shows the stone steps leading up to St. Peter's Catholic Church. This photo was taken sometime in the late 1800s. Today a railing is attached to the steps for safety. In this photo, you can see where the steps were chiseled out of the original stone. (Courtesy of the Historic Photo Collection, Harpers Ferry National Historical Park.)

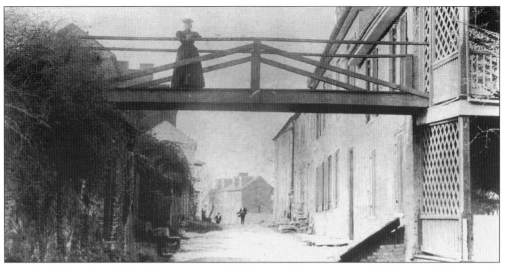

HARPER HOUSE AND MARMION ROW. Taken April 14, 1898, this photograph shows a woman standing on the Harper House pedestrian bridge. Some sources say this is an heir of Robert Harper, founder of Harpers Ferry. The architectural detail of Marmion Row buildings and Harper House is very good. In the distance are people walking along Marmion Row, which connects to High street at the far end. (Courtesy of the Historic Photo Collection, Harpers Ferry National Historical Park.)

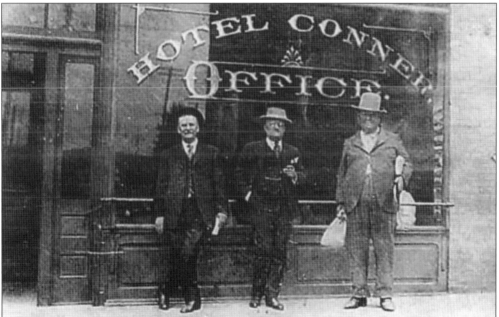

HOTEL CONNER, 1910. Located on Shenandoah Street on the original site of the U.S. Arsenal, the hotel was torn down after the damage caused by the flood of 1936. T. Conner was the manager and proprietor of the hotel. The costs to stay at the Conner were $2 per day and up. It offered steam heat, artesian water, electric lights, electric call bells, hot and cold baths, and good meals. It advertised the American plan and called itself the "headquarters for traveling men." Fishermen were provided with guides and bait at short notice. (Courtesy of the Historic Photo Collection, Harpers Ferry National Historical Park.)

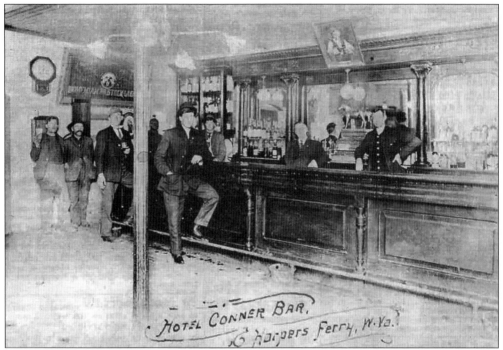

HOTEL CONNER BAR, C. 1910–1915. Notice the men in jackets and ties. The Conner Hotel was located on Shenandoah Street and was managed and owned by a Mr. T. Conner. (Courtesy of the Historic Photo Collection, Harpers Ferry National Historical Park.)

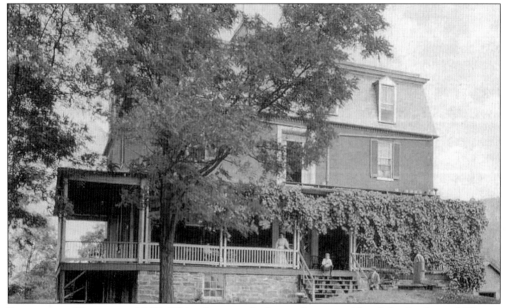

LOCKWOOD HOUSE, C. 1915. This photograph shows the west side of the Lockwood House. People can be seen on the porch, the steps, and in the yard. Vines cover part of the porch. This photo was copied from a postcard. The Lockwood House still had its third floor addition at this point. It was later removed to have the building more closely resemble its original appearance. (Courtesy of the Historic Photo Collection, Harpers Ferry National Historical Park.)

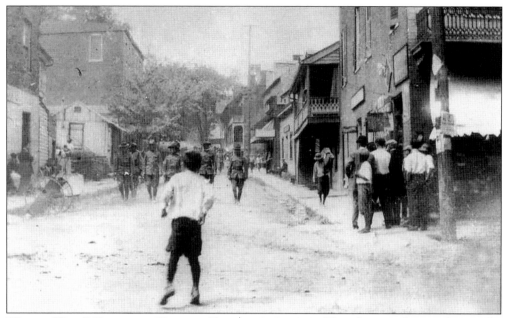

WORLD WAR I TROOPS IN HARPERS FERRY, 1917–1919. This photograph was taken at the corner of High Street and Shenandoah Street. It shows troops marching in formation down High Street as spectators stand on the corner watching. The young boy in the street seems mesmerized by them. (Courtesy of the Historic Photo Collection, Harpers Ferry National Historical Park.)

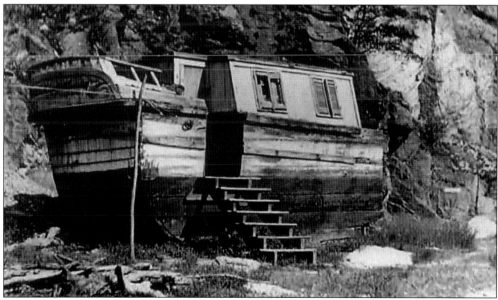

CANAL BOAT, RETIRED. This Chesapeake and Ohio Canal boat was converted into a residence in the Maryland Heights area. The photograph dates from sometime after 1924, when the canal closed. What happened to other boats is unknown, but the Erie Canal alone had 4,191 boats to dispose of. Most boats were 60 to 80 feet long and 14-feet wide. When in use, they were pulled by horses or mules that were changed every 15 miles. (Courtesy of the Historic Photo Collection, Harpers Ferry National Historical Park.)

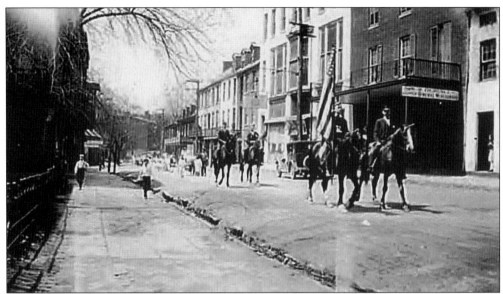

MAY DAY PARADE, 1928. The parade is pictured on Shenandoah Street. Two men mounted on horses lead the parade, one carrying a flag. Other mounted men follow. Women or girls can be seen in the distance, possibly nurses. In addition, two young boys are on the south sidewalk. The fence visible on the left is part of the Master Armorer's fence. (Courtesy of the Historic Photo Collection, Harpers Ferry National Historical Park.)

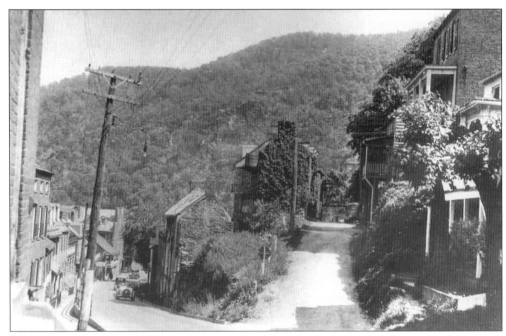

HIGH STREET, C. 1930. High Street is paved but Marmion Row is still a dirt road in this image, looking down High Street towards the main business district. In the distance, Loudon Heights can be seen, with ample vegetation. The houses along Marmion Row have much more vegetation than in previous photographs. (Courtesy of the Historic Photo Collection, Harpers Ferry National Historical Park.)

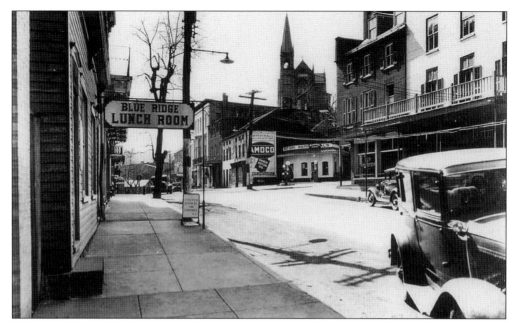

SHENANDOAH STREET, 1932. This photograph was taken from the east end of Shenandoah Street, looking west. St. Peter's Catholic Church can be seen in the middle of the photograph, behind the stores. The corner in the photograph is the corner of High and Shenandoah Streets. The building to the immediate right now houses John Brown's Museum. Many of the buildings on the left no longer exist. (Courtesy of the Historic Photo Collection, Harpers Ferry National Historical Park.)

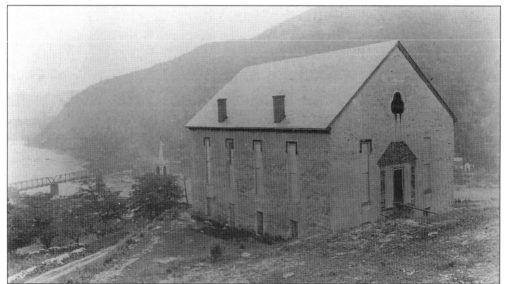

ST. JOHN'S EPISCOPAL CHURCH. Pictured sometime in 1889–1890, the church was rectangular in shape with two stories, a gabled roof, and a projected foyer. It had one round window and the other window openings were Tudor with Gothic arches. In addition, it had a trefoil window. It originally had an open plan with a rear gallery. The ruins of this church remain a picturesque landmark. In the background can be seen the river gap. (Courtesy of Historic Photo Collection, Harpers Ferry National Historical Park.).

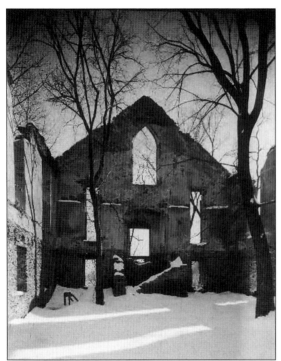

RUINS, ST. JOHN'S EPISCOPAL CHURCH. Everyone who climbs the hill to Jefferson Rock looks at the picturesque ruins with questioning eyes. It was built between 1851 and 1852 and was originally a simple stone front building with elementary Gothic Revival details. Materials of construction included limestone rubble with stucco walls. During the Civil War it was damaged, and rebuilt in 1882. A new church was constructed in 1895-1896 and use of the original was discontinued. (Courtesy of Library of Congress, HABS, WVA, 19-HARF, 19-5.)

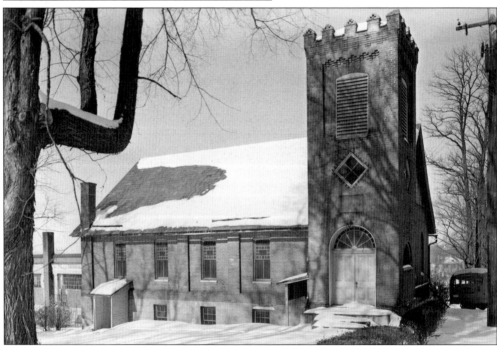

CURTIS FREEWILL BAPTIST CHURCH. Named in honor of the Rev. Silas P. Curtis of New Hampshire, the church was built between 1889 and 1896. It is a red brick building, two-story, with the upper floor containing the church auditorium. The lower floor originally had a classroom, a library, a vestry room, and a kitchen. (Courtesy of the Library of Congress, HABS, WVA,19-HARF,30-1.)

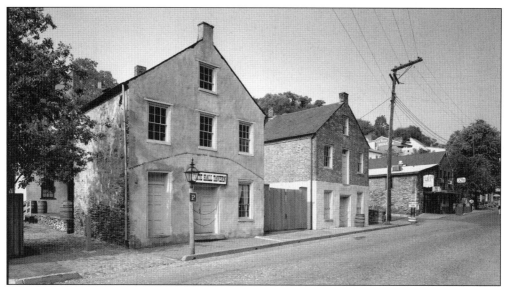

WHITE HALL. Located on Potomac Street near Shenandoah Street, White Hall was part of the original Wager Six Acre site. Built in 1839, it has been used as a warehouse, a tavern, and a residence. Originally only 24 by 40 feet, it became smaller yet when Potomac Street was widened. According to the 1880 census, stonecutter John Fitzpatrick lived here. It consists of two stories with one room each, a dirt floor basement, attic, the original slate roof and walls that vary from 10 inches to two feet. (Courtesy of the Library of Congress, HABS, WVA, 19-HARF, 18-1.)

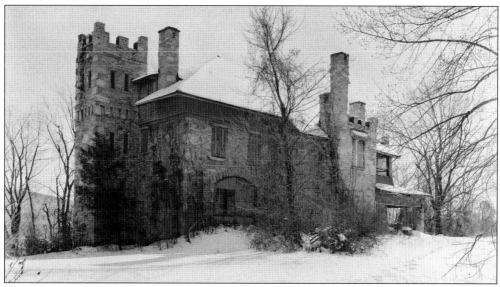

SCOTTISH CASTLE. After the Civil War, a Union officer of Scottish background came back to the area and built this building on Bolivar Heights. It existed for 100 years on the site of what is now National Park service land. It was built on the site of a Civil War engagement. In 1961, the National Park Service destroyed it because it was abandoned and in poor condition. It was built as an elaborate period revival home, designed to resemble a medieval castle. Interesting murals covered the walls throughout the interior. (Courtesy of the Library of Congress, HABS, WVA, 19-HARF.V,1-1.)

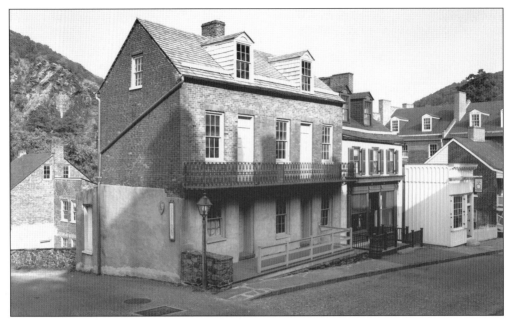

FREDERICK A. ROEDER HOUSE. The Roeder house is located on the northeast corner of High Street and Hog Alley. In this picture, looking down the hill to the right is Shenandoah Street. The original house was built between 1844 and 1845. It was designed as a two-story building but was enlarged about five years after it was built. The building served as a bakery before the Civil War. (Courtesy of Library of Congress, HABS, WVA, 19-HARF, 16-4.)

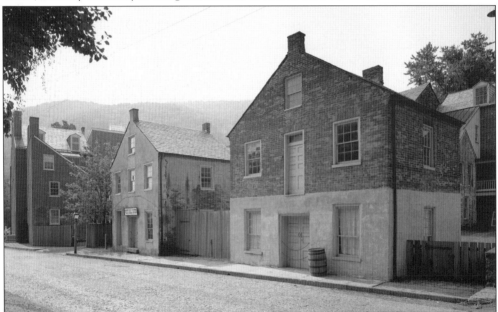

ROEDER STORE. This view is taken from the north and shows both the Frederick A. Roeder Store and the White Hall Tavern. Located on Potomac Street, the Roeder Store was built in 1856 and served as a business establishment until 1865, serving as a warehouse, a drinking house, or a confectionary. (Courtesy of the Library of Congress, HABS, WVA, 19-HARF, 17-7.)

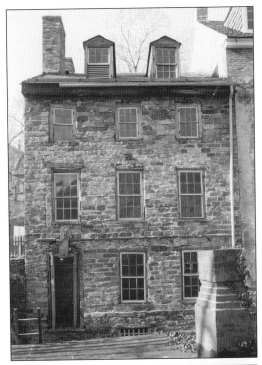

HARPER HOUSE, EAST ELEVATION. This is a photograph of the East (Front) elevation of Harper House, also called the Wager Mansion, in Harpers Ferry, West Virginia. Robert Harper began the construction of this house but never lived in it because he died before it was completed. His heirs completed the construction in 1792. Jack E. Boucher took this photograph. (Courtesy of the Library of Congress, HABS, WV, 19-HARF, 10-.)

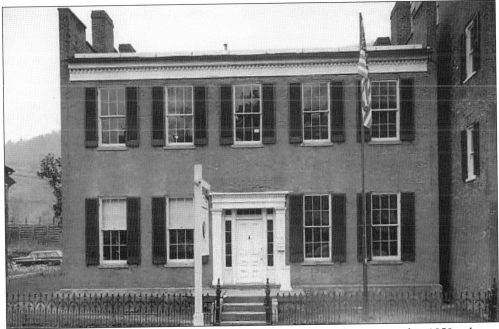

MASTER ARMORER'S HOUSE. Located on Shenandoah Street and constructed in 1859 to house the Master Armorer of the Harpers Ferry Armory, this two-story center-hall plan has an entrance with transom and sidelights, and a gable roof. During the Civil War, it served as officers' quarters for both sides. In the 1960s, it was restored by the Park Service and is now part of the Harpers Ferry National Historical Park. (Courtesy of the Library of Congress, HABS, WVA, 19-HARF,12-1.)

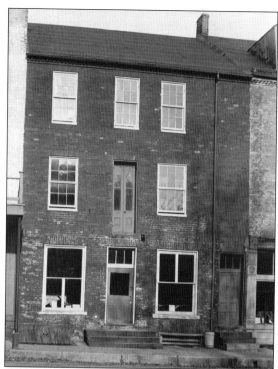

JOHN C. UNSELD BUILDING. Built in the 1830s and located near John Brown's capture, there is no evidence this building was used by any raid participants. Robert Harper originally owned the land; the building was erected between William Anderson and Gerard B. Wager buildings, with the Unseld sidewalls as adjacent sidewalls of the other two. The roof, with a pitch of 8-12 inches, originally had a pitch of 9-19 inches. Living quarters occupied the second and third floors. (Courtesy of the Library of Congress, HABS, WVA,19-HARF,22-1.)

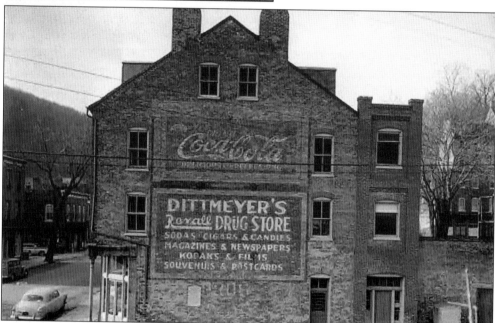

GERARD B. WAGER BUILDING. Located near the B&O Railroad and former Armory and Arsenal, this building is on the corner of Potomac and Shenandoah Streets. Part of the foundation is from a previous dwelling that could possibly have been the site of Robert Harper's original house. Built between 1836 and 1839 to be used both as a residence and a store, Walter Dittmeyer purchased it in 1914 and opened his pharmacy. (Courtesy of the Library of Congress, HABS, WV,19-HARF,23-1.)

THE ARMORER'S DWELLING HOUSE. The Armorer's House, constructed in the mid-1800s, housed the armorer and his family. It is located on Shenandoah Street. Made from coursed fieldstone rubble with brick saw-tooth cornices, some of the original woodwork survives, such as mantels. This house was typical for workers at the Armory. The shape is rectangular, two stories, an attic and a steep gable roof. It is now part of the Harpers Ferry National Historical Park. (Courtesy of Library of Congress, HABS, WVA, 19-HARF, 5-8)

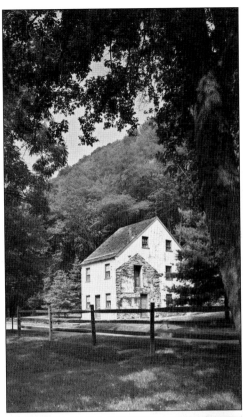

MASONIC HALL. This building, constructed between 1844 and 1845, housed the Masonic Hall on the third floor until 1952. Over the years, various businesses used the lower floors, such as a saddle factory, clothing store, possibly a bakery, a plumber, a butcher, and others. The building was occupied by troops during the Civil War. The unusual vaulted hall ceiling was constructed with wood from the "gundalows" that carried supplies on the Shenandoah River. In the 1960s, alterations to the building were made when rest rooms were installed. (Courtesy of the Library of Congress, HABS, WVA, 19-HARF,31-1.)

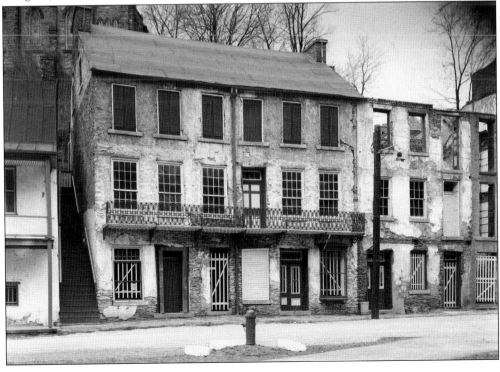

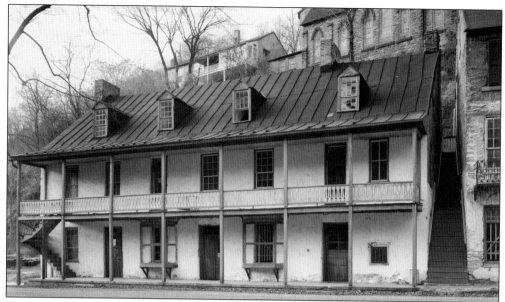

JOHN G. WILSON BUILDING. Historically, this building has been called the Stagecoach Inn. Built between 1825 and 1826, it consisted of stores on the first level with private dwellings above. In 1830, it was converted to a hotel. In addition, during the Civil War it was used as troop quarters. It is located in Lower Town Harpers Ferry, on the northwest side of Shenandoah Street and today houses the Harpers Ferry bookstore. (Courtesy of the Library of Congress, HABS, WVA, 19-HARF,20-1.)

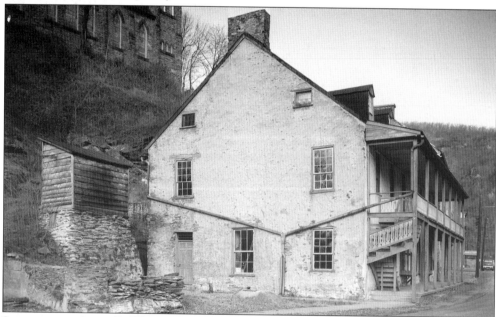

SOUTHSIDE OF JOHN G. WILSON BUILDING. This view shows the southern side of the John G. Wilson Building. The building today houses the bookstore on the main floor. Here, books and other items pertaining to Harpers Ferry and its history may be purchased. The upper floors are used for storage. St. Peter's Catholic Church can be seen on the upper left corner of the photo. (Courtesy of the Library of Congress, HABS, WVA, 19-HARF, 20-2.)

PRIVY, JOHN G. WILSON BUILDING.
At the time of the John Brown Raid,
outside toilets or privies were
commonplace. And in areas where the
plumbing was available, the common man
either did not know or understand the
connection between bacteria and disease or
could not afford indoor plumbing.
(Courtesy of the Library of Congress,
HABS, WVA, 19-HARF, 20A-3.)

SUSAN DOWNEY HOUSE. The Susan
Downey House was built in 1838 to 1839
by William Anderson. The kitchen wing
was probably added in 1941. The house sits
on land that was originally part of the
Wager Six Acre. It has served as a private
residence, a store, a rooming house, a
boarding house, and a tavern. It is called
the Susan Downey House because she
purchased it in 1846. The L-shaped house
has two and a half stories, was heated by
eight fireplaces, and has a basement (dirt
floor under the original portion). The stone
walls vary in thickness from one foot eight
inches to two feet ten inches. (Courtesy of
the Library of Congress, HABS, WVA, 19-
HARF, 9-2.)

TEARNEY BUILDING. The Tearney Building is located on Shenandoah Street. The building was probably named after James A. Tearney. Tearney had at least one child, a son named John. The Tearney family eventually moved to Leavenworth County, Kansas, west of Lowemont. Tearney and his son were both stonemasons. His son married Mary Ann Gale. (Courtesy of the Library of Congress, HABS, WVA, 19-HARF, 8-1.)

JOHN B. TEARNEY AND HIS WIFE, MARY ANN GALE. This formal portrait was taken in 1880. He had moved to Kansas in 1868 with his parents. President James Buchanan gave his uncle, Edward Tearney of Harpers Ferry, West Virginia, the land in Kansas in a grant. Both John and his father were stonemasons and bridge builders. From 1918 until 1929, they built most of the highway bridges and culverts in eastern Kansas and western Missouri. (Courtesy of the Historic Photo Collection, Harpers Ferry National Historical Park.)

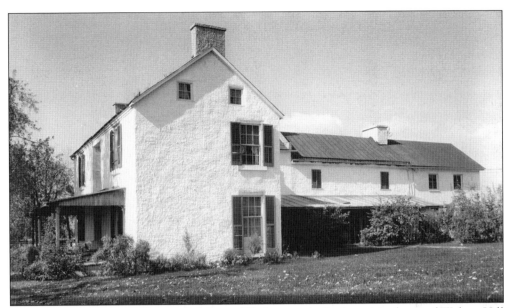

WALNUT HILL. Near Halltown, Col. Lewis Washington built the original part of Walnut Hill for his son. Col. Lewis Washington was one of the prominent citizens captured by the raiders and held hostage during the John Brown raid on the Arsenal in 1859. Changes have been made to the house over the years—the exterior has been plastered over, the original one story porch has been removed, and the interior trim has been altered. (Courtesy of the Library of Congress, HABS, WVA, 19-HALTO.V, 1-2.)

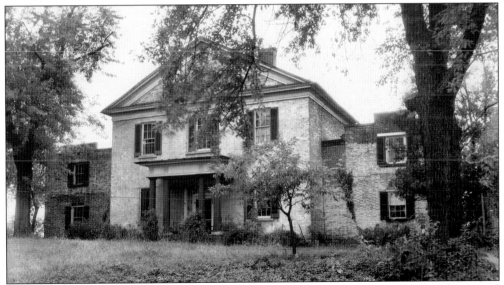

HAPPY RETREAT. Charles Washington built this home soon after the Revolution. The central part was added in 1833 by Judge Douglas who renamed it "Mordington." The wings are original. The field where John Brown was hanged is visible from this property. In addition, the "Happy Retreat" is visible in a sketch in which the artist drew the scaffolding and John Brown hanging from the rope, with hundreds of soldiers surrounding the field. The sketch mentioned here is found in the chapter on John Brown, page 22 of this book. (Courtesy of the Library of Congress, HABS, WVA,19-CHART,5-1.)

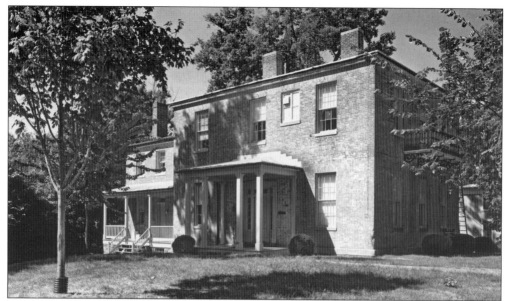

MORRELL HOUSE. Erected between 1857 and 1858, this building was to serve as a residence for one of the chief clerks of the Armory. The land, originally owned by John Wager, was sold to the U.S. Government for the Federal Armory in 1796. Originally identical to the Bracket house, it was deeded to Storer College. Alexander H. Morrell and his family occupied the residence—it was named in honor of him for his contributions to Storer College. (Courtesy of the Library of Congress, HABS, WVA, 19-HARF, 13-8.)

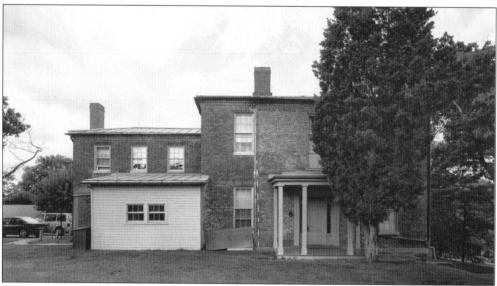

THE REV. NATHAN BRACKET HOUSE. Authorized by Congress in 1856, this house was constructed between 1857 and 1858 for armory officials. It echoed the design of the paymaster's and superintendent's houses, but was fashioned to communicate the lower rank of the residents. Nathan and Louise Brackett lived here at the time Storer College was founded, which explains the name. It was called a "year round boarding house" because as many as 23 lived in the house (13 students) according to the 1880 census. (Courtesy of the Library of Congress, HABS, WVA, 19-HARF, 33-1.)

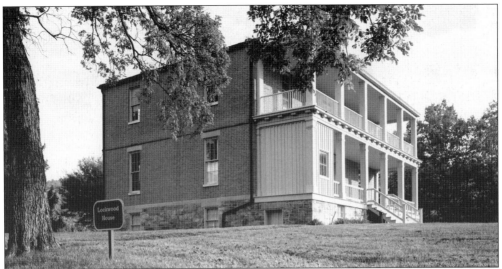

PAYMASTER'S QUARTERS. This building was constructed by the U.S. Government between 1847 and 1848 and used as a residence for the paymaster until 1861. After Storer College was established, the building was donated and used for school purposes, as well as a hotel. The interior has a center stair hall with stairs leading to the basement and the second floor. The thickness of the walls varies from one foot two inches to one foot eight inches. (Courtesy of the Library of Congress, HABS, WVA, 19-HARF, 14-12.)

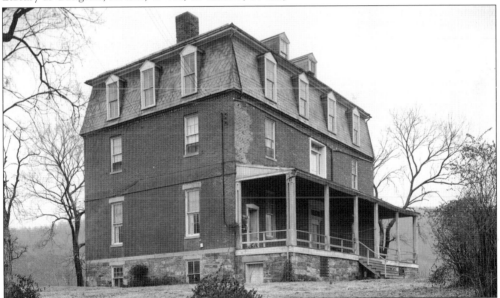

PAYMASTER'S QUARTERS WITH ADDITION. This photo shows the Paymaster's Quarters on Camp Hill, with an addition that was added and later removed to make the building more closely resemble its original structure. During the Civil War, both Gen. Phillip H. Sheridan and General Lockwood used it as headquarters. The residence was used and abused by both people and horses. Julia Mann, niece of educator Horace Mann, opened the first school to teach "refugee slaves" in this building. This later developed into Storer College, to which the building was eventually deeded. It later became known as the Lockwood House. (Courtesy of the Library of Congress, HABS, WVA, 19-HARF, 14-1.)

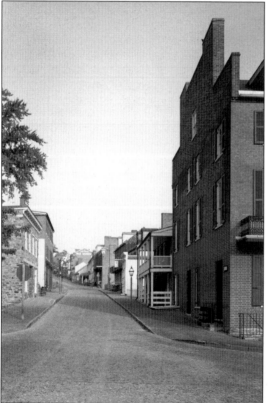

CHARLES TOWN COURTHOUSE. The courtroom where John Brown was tried and convicted, the room has been changed since with the erection of the partition. The courthouse sits on land that was given to Charles Town for public use by Charles Washington, brother of President George Washington. During the Civil War, the building was partially destroyed. In 1872, the county seat was moved to Shepherdstown, until the building was renovated and enlarged in 1887. Two of the three trials for treason in the U.S. were held in this building, one of those being the trial of John Brown. (Courtesy of the Library of Congress, HABS, WVA,19-CHART,3-11.)

LOOKING UP HIGH STREET. This photograph was taken at the corner of High and Shenandoah Streets, looking north. The building on the right houses the John Brown exhibit. Further up on the right, the little white building just after the light is the old jewelry store. (Courtesy of the Library of Congress, HABS, WVA, 19-HARF, 3-7.)

Seven

TRANSPORTATION

Transportation, both on land and water, was the founding father of Harpers Ferry. You could say that Harpers Ferry was created and defined by the transportation systems that have served it. Had John Harper not seen the potential of his ferry, the town might not have developed into the thriving community that it did. Moreover, had George Washington not noticed the availability of the waterpower and felt compelled to place an armory and arsenal in Harpers Ferry, the town might not have played such an important role in our nation's history. Little did either of them know that both land and water transportation would mold, define, and identify Harpers Ferry.

The 1800s brought the C&O Canal, the Winchester and Potomac Railroad, and the Baltimore and Ohio Railroad. Both railroads had depots on the original Ferry Lot. (The Ferry Lot was the parcel of land over which Harper's heirs maintained control for many years.) At one point as many as 28 trains a day came to Harpers Ferry.

Once established as a thriving community, Harpers Ferry was served well by the two rivers, railroads, and highways. However, Mother Nature and her waterways had other things in mind and would continually wreak havoc on Harpers Ferry's transportation systems. Harpers Ferry, however, would not succumb to defeat and continually came back, time and again with new bridges, more bridges, stronger bridges, until the current day. And, as Harpers Ferry has evolved, the transportation systems have continued to evolve with it with the most recent highway bridge being completed in the fall of 1999, spanning the Shenandoah River.

Railroads still pass through Harpers Ferry today, including both freight trains and the Marc train that provides commuters with daily train service into Washington, D.C.

While the waterways no longer provide transportation for goods and services, they do serve as recreational centers for the whitewater rafting and tubing offered by professional guides.

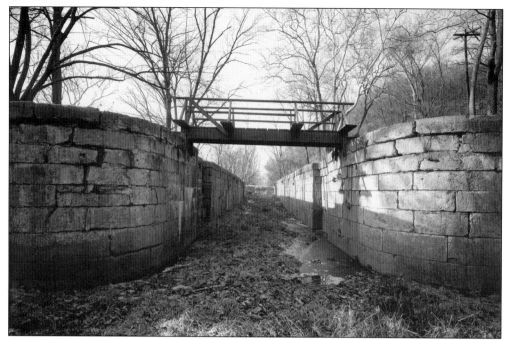

C & O Canal. Lock 34 (a lock is an enclosure used in canals to raise or lower boats as they pass from one level to another) on the C & O Canal is shown here. The American canal system did not replace the river system, but served as a complimentary system to it. While the rivers were often tumultuous and followed the whim of the elements, the canals were mostly calm and more pleasant. They were awesome engineering achievements, often through almost impossible terrains. (Courtesy of Library of Congress, HABS, MD, 22-HARF, V, 8-2.)

Mason's Marks. This photograph shows the marks made by a mason after he finished working on this lock. In this case, the mason's mark is a little triangle visible on the third level of blocks, the left side of the right hand block (one down from the top). It was his "signature," so to speak. The C&O Canal was known for its special quality of stonework, considered without equal. The C&O Canal employed many people—in 1829 there were 3000 working on it, and ten years later an additional 2000. Laborers working on the canals often lived 15 to 20 under one roof. If families came along, they were housed in primitive huts. (Courtesy of the Library of Congress, HABS, MD, 22-HARF, V, 3-3.)

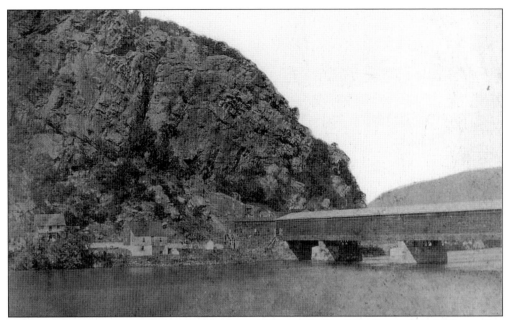

COVERED BRIDGE, 1859. The bridge is seen in 1859, just before John Brown's raid. The raiders entered from the Maryland side of the bridge. You can see Maryland Heights and the C&O Canal Wall. You can also see that the bridge is protected with weatherboards and sits on stone piers in the Potomac River. As John and his men crossed the bridge, they could not be seen. However, they could be heard, as the watchman found out very quickly. (Courtesy of the Historic Photo Collection, Harpers Ferry National Historical Park.)

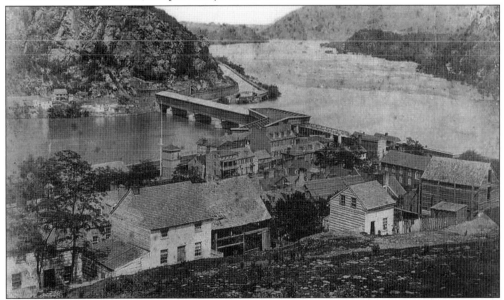

COVERED BRIDGE, 1859. Here is another view of the covered bridge, taken in 1859. The photo was taken from Camp Hill, near the Episcopal church. You can see a good view of the C&O Canal on the Maryland shore. The large Arsenal, the Armory flagpole, the Musket Factory building #3, and the rocky slopes of Maryland Heights can all be seen. (Courtesy of the Historic Photo Collection, Harpers Ferry National Historical Park.)

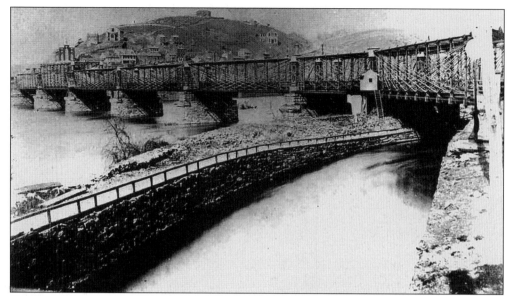

THE IRON BRIDGE. In 1866, this photograph was taken that shows the Potomac Iron Bridge from the Maryland side. In the foreground is one of the canals of the C&O Canal system. Also visible is Camp Hill, which served as grounds for encampments for both forces at alternating times during the Civil War. (Courtesy of the Historic Photo Collection, Harpers Ferry National Historical Park.)

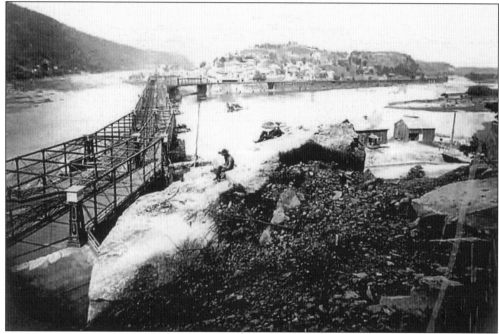

THE BOLLMAN BRIDGE. In 1870, the Bollman Bridge was completed. At that time, it carried both highway traffic and the tracks of the Baltimore and Ohio Railroad across the Potomac River. This photograph was taken from atop Maryland Heights. The all too frequent floods that ravaged serene Harpers Ferry over the years later destroyed the bridge. (Courtesy of the Historic Photo Collection, Harpers Ferry National Historical Park.)

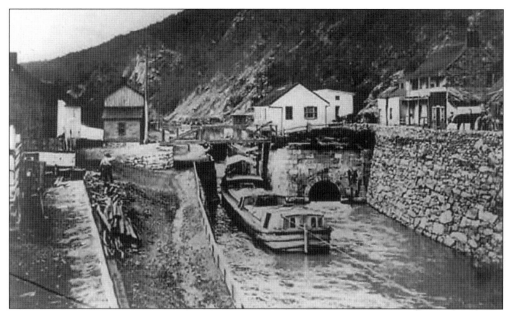

LOCK 33. Lift Lock 33 of the C&O Canal system is pictured in 1876; the image shows the lock, the lock house, and canal boats going through the lock. This lock was opposite Harpers Ferry on the Maryland side of the Potomac River, beneath Maryland Heights. The C&O Canal system was built for roughly $14 million. Goods that traveled on the canal included flour and coal. George Washington was the first historian of the C&O Canal. (Courtesy of the Historic Photo Collection, Harpers Ferry National Historical Park.)

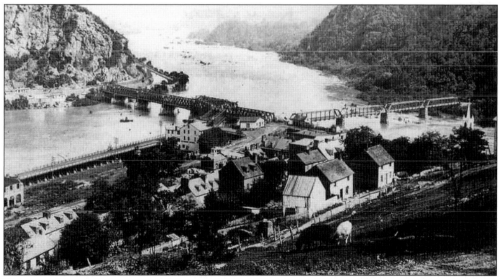

HARPERS FERRY BETWEEN 1886 AND 1887. This view of Harpers Ferry was taken by W.C. Russell and shows two rivers converging, the Potomac on the left and the Shenandoah on the right. Maryland Heights appears quite barren and rocky with little vegetation. The photo was taken just above Church Street. The Musket Factory and the Armory office building have been demolished. Two cows graze in what was then pasture. To the right is the steeple of St. Peter's Catholic Church, which still stands today. (Courtesy of the Historic Photo Collection, Harpers Ferry National Historical Park.)

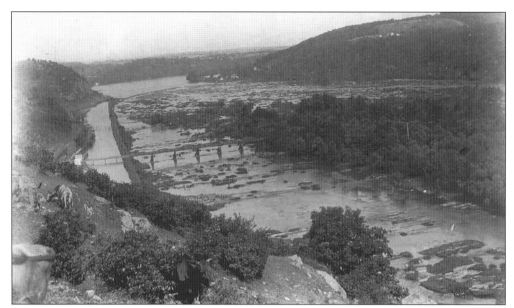

ISLAND PARK. Taken in 1895 from Camp Hill, this photograph offers a good view of Island Park and the Island Park Bridge. Taken by Professor Seaman, the photograph shows the Old Armory Canal, which is perpendicular in the picture to the bridge that crosses to Island Park. It was on Island Park that picnics were held. It was operated by the Baltimore and Ohio Railroad. (Courtesy of the Historic Photo Collection, Harpers Ferry National Historical Park.)

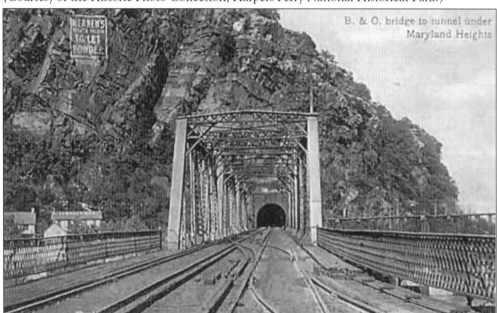

THE B&O RAILROAD BRIDGE, 1908. This view across the old iron B&O Railroad Bridge shows the original tunnel before it was widened. It also shows the rocky cliffs of Maryland Heights with an advertisement on the side. The sign reads, "Mennen's Borate Talcum Toilet Powder." Ads such as this were geared for the passengers on trains. Maryland Heights has since become overgrown with vegetation. (Courtesy of Historic Photo Collection, Harpers Ferry National Historical Park.)

THE RAILROAD DEPOT. Taken about 1910, this photograph shows the railroad station in its original place at "The Point." This view shows the arrangement and layout of the Baltimore and Ohio Railroad platform including the tracks and station, which were later moved to the present-day location. Railroad workers can be seen on the tracks and passengers can be seen near the station. (Courtesy of the Historic Photo Collection, Harpers Ferry National Historical Park.)

THE ORIGINAL B&O TUNNEL. The original tunnel for the Baltimore and Ohio Railroad was built in 1894. It was enlarged in 1930. At the same time, a new railroad bridge was built. This photograph was taken in 1930, before construction began. (Courtesy of the Historic Photo Collection, Harpers Ferry National Historical Park.)

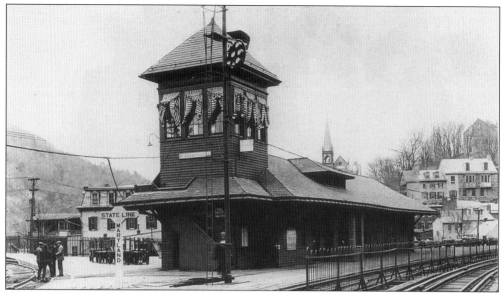

THE B&O RAILROAD STATION. Pictured here on November 12, 1930, is the B&O Railroad station at its original location, at the junction of the Potomac and Shenandoah Rivers. It was erected in 1892 and stayed in the same location until it was relocated in 1931 to the new railroad bridge site. A group of men can be seen close to the tracks and a baggage wagon can be seen on the platform. The station appears to be decorated in a patriotic theme. (Courtesy of the Historic Photo Collection, Harpers Ferry National Historical Park.)

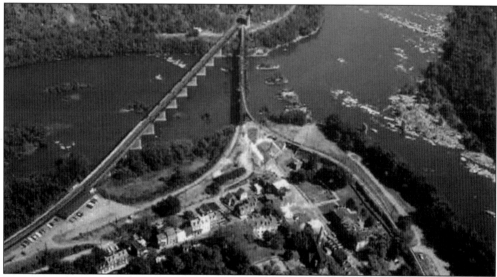

THE POINT. This is an aerial view of The Point in Harpers Ferry, looking east towards Maryland Heights. The B&O Bridge, completed in 1931, and the 1894 bridge to the Winchester, Virginia, branch are visible. The piers of the former Bollman Bridge, which were washed out in the flood of 1936, are visible in the Potomac River just before the Shenandoah River joins it. To the extreme right of the picture are the stone piers from a former highway bridge, long since gone. The Shenandoah River comes in from the right, to join the Potomac River, which comes in from the left. They form one river, The Potomac, and flow to the Chesapeake Bay. (Courtesy of the Library of Congress, HAER, MD, 22-HARF. V, 1-1.)

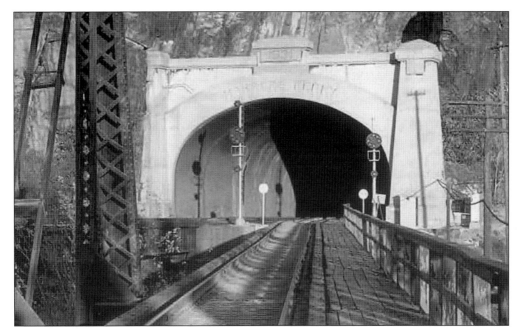

THE WEST PORTAL. This is a close up of the tunnel that goes into the side of the mountain on Maryland Heights. The railroad lines belong to the Baltimore and Ohio Railroad and are coming from Harpers Ferry. The tunnel is located on the North bank of the Potomac River, opposite Harpers Ferry. (Courtesy of the Library of Congress, HAER, MD, 22-HARF.V,2-1.)

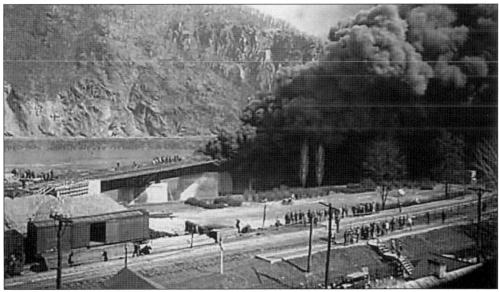

FIRE RAGES. A fire rages on the B&O Railroad Bridge as it was nearing completion in March 1931. It was suspected that hot rivets started the fire. This view was taken from High Street looking down on the site. The railroad land, with tracks in foreground, was the former Armory site. The new bridge at about the fourth pier out in the river is burning. The thick black billows of smoke block part of the view of Maryland Heights. Workmen and others can be seen standing and watching the fire. (Courtesy of the Historic Photo Collection, Harpers Ferry National Historical Park.)

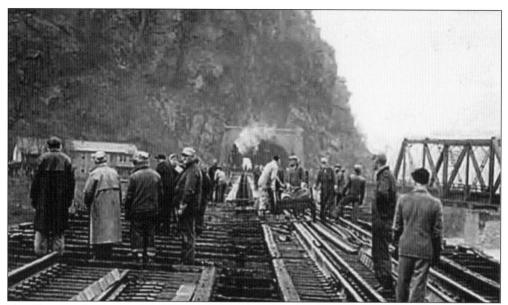

THE DAMAGE INSPECTED. In March 1931, railroad workers inspect the fire damage to the new Baltimore and Ohio Railroad Bridge. The bridge was damaged by a construction fire that charred ties and warped rails. Railroad workmen and a steam engine can be seen near the tunnel entrance. This view was taken looking east. The fire was believed to have started from hot rivets. In the background, an old stone house and the Salty Dog Saloon can be seen on the Maryland Heights side of the Potomac River. (Courtesy of the Historic Photo Collection, Harpers Ferry National Historical Park.)

THE B&O BRIDGE, NEW CONSTRUCTION. This photograph shows the new Baltimore and Ohio Railroad Bridge, which was built in April 1931. Shown here is Span number 6, and Girders 3 and 4. In the distance, you can see the lock-tender's house and the Salty Dog Tavern located at Lock 33 of the C&O Canal. The rocky cliff is Maryland Heights. (Courtesy of the Historic Photo Collection, Harpers Ferry National Historical Park.)

The Tunnel is Enlarged. In June 1931, the tunnel for the Baltimore and Ohio Railroad was enlarged. It was originally completed in 1894. It was enlarged along with the construction of a new railroad bridge across the Potomac River. The Valley Line tracks are shown in the foreground. The new mainline piers, without girders, are on the left. (Courtesy of the Historic Photo Collection, Harpers Ferry National Historical Park.)

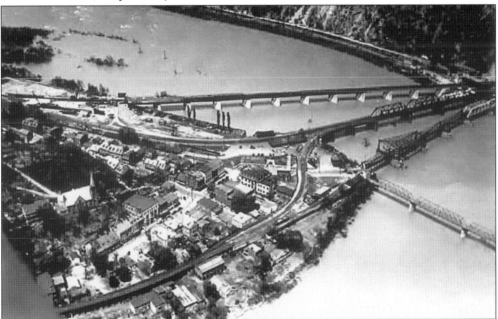

The B&O Bridge, Aerial View. The new Baltimore and Ohio Railroad Bridge can be seen in this photograph at the top center. The original 1894 passenger depot is still in its original position in this photograph; it will be moved later. All of the buildings in the foreground, between the railroad tracks and the Shenandoah River, are no longer in existence, nor is the bridge that transverses the Shenandoah River to the right. (Courtesy of the Historic Photo Collection, Harpers Ferry National Historical Park.)

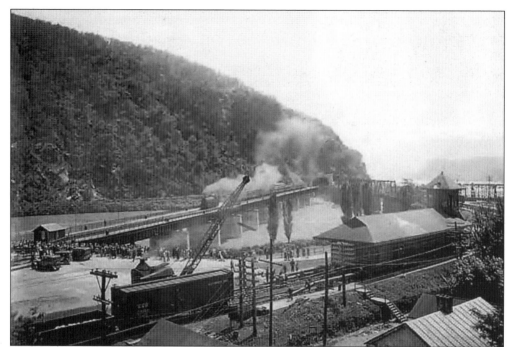

B&O Train Station Moves. The Baltimore and Ohio Railroad station remained in its original 1894 location until it was moved in 1931. Here you can see the station being moved on a platform along the railroad, quite a feat to accomplish. Today, the same station is still in service, serving both Amtrak passengers and MARC rail commuters. (Courtesy of the Historic Photo Collection, Harpers Ferry National Historical Park.)

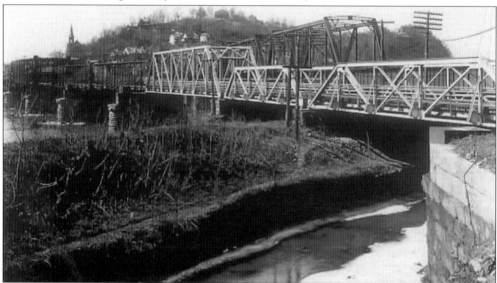

The Bollman Bridge Spans Replaced. The Flood of 1924 washed away three sections of the Bollman Bridge. In this photo, the three steel spans have been replaced. The Chesapeake and Ohio Canal in the foreground was abandoned after the flood of 1924. This photograph is dated February 16, 1933. In the distance is Camp Hill; to the right (out of sight) is Maryland Heights. (Courtesy of the Historic Photo Collection, Harpers Ferry National Historical Park.)

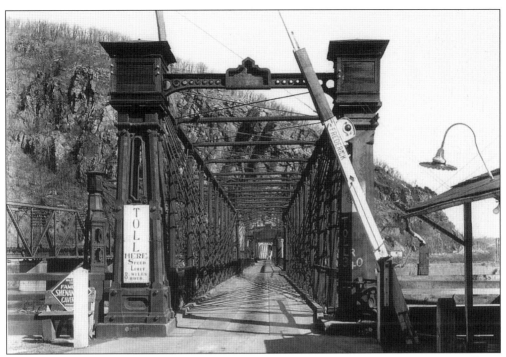

THE TOLL GATE ON BOLLMAN BRIDGE. This photograph shows the tollgate on Bollman Bridge at The Point on February 16, 1933. The sign on the left of the entrance post reads, "Toll Here Speed Limit 8 miles per hour." "Frederick" is painted on the train gate on the right, just below the signal light. The bridge is long gone because of the flood of 1936, but the iron cross belongs to the Park exhibit collection. (Courtesy of the Historic Photo Collection, Harpers Ferry National Historical Park.)

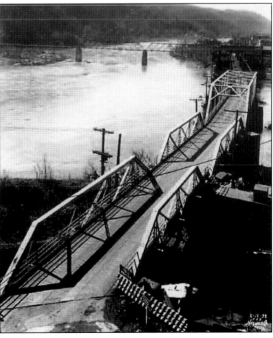

THE BOLLMAN BRIDGE NEW SPANS. This view shows the three new steel spans on the Bollman Highway Bridge. The photograph is dated February 16, 1933, and taken from the Maryland side of the river below Maryland Heights. In the distance on the left is Loudoun Heights; at the end of the bridge is The Point and Harpers Ferry. (Courtesy of the Historic Photo Collection, Harpers Ferry National Historical Park.)

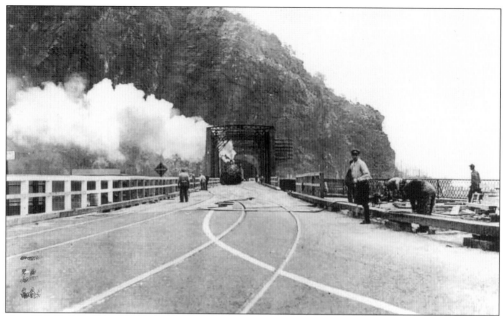

THE B&O FREIGHT BRIDGE. This photograph was taken after the flood of 1936. The 1894 Baltimore and Ohio Railroad Bridge is undergoing resurfacing to convert the bridge for automobile usage. The Bollman Bridge, which was adjacent to this bridge, had been used as a highway bridge since 1894. The flood of 1936 destroyed the Bollman Bridge. The newly resurfaced bridge was put into vehicular use on August 26, 1936. (Courtesy of the Historic Photo Collection, Harpers Ferry National Historical Park.)

THE LAST SPAN. In the flood of 1936, three spans of the Shenandoah River Bridge were washed away. This is a photo of the last remaining span. The bridge is barricaded for safety. To the left you can see a sign that reads, "Shenandoah River" and "Toll Bridge." To the right is a wooden structure that served as the Stevenson Store, with a gas pump out front. (Courtesy of the Historic Photo Collection, Harpers Ferry National Historical Park.)

Eight

FLOODS IN
HARPERS FERRY

If Harpers Ferry had a middle name, it would be "floods." There have been 46 recorded floods at the confluence of the Shenandoah and Potomac Rivers, an average of a flood every five and a half years. Some were worse than others.

It started in 1748 when Robert Harper was driven from his log cabin by floodwaters. In the year 1753 the "Pumpkin Flood" occurred, so named because the Indian pumpkin gardens washed out. In 1852, the town experienced the worst flood since the settlers first arrived. In 1870 the residents on Virginius Island were trapped and unable to escape because floodwaters rose rapidly, and 42 died. In 1877, considerable damage was done to the C&O Canal, the waters crested at 29.2 feet, and the Old Shenandoah Canal closed for good. In 1889 the waters peaked at 34.8 feet and the Shenandoah wagon bridge was destroyed. The rivers reached 33.0 feet in 1896. Three spans of the Bollman Bridge were swept away in 1924, and the C&O Canal was permanently closed after the river rose to 27.6 feet. A 1936 flood swept away the Bollman and Shenandoah Bridges for good, with rivers reaching 36.5 feet. The floodwaters in 1942 crested at 33.8 feet. Hurricane Agnes, in 1972, contributed to the 29.7 feet floodwater level. In 1985, floodwaters peaked at 29.8 feet.

For the first time in history, in the year 1996, there were two floods over 29 feet in one year. The January 20 through 21, 1996, blizzard brought two feet of snow to the valleys of the Potomac and Shenandoah Rivers, causing them to rise to up to 29.4 feet. Later that year, on September 8, rain from Hurricane Fran caused the river to rise to 29.8 feet.

Floods or not, Harpers Ferry has an indomitable spirit and will never be completely destroyed, just temporarily inconvenienced by Mother Nature.

YEARS OF RECORDED FLOODS

1748	1861	1896	1924	1950
1753	1862	1897	1928	1954
1810	1863	1898	1929	1955
1832	1865	1899	1932	1972
1839	1870	1901	1936	1975
1840	1877	1902	1937	1985
1843	1889	1908	1942	1987
1846	1891	1910	1945	1993
1860	1893	1913	1949	

1996 (two this year)

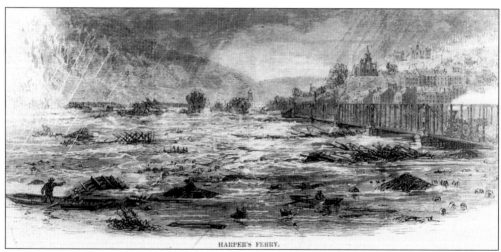

THE FLOOD OF 1870. This sketch of the flood of 1870 appeared in Harpers Weekly, October 22, 1870, page 676. This view of the Potomac River flood was taken from the Maryland shore. The Catholic church can be seen on the right, along with the Lockwood House, Marmion Row, and the Harper House. In this devastating flood, 42 people lost their lives. (Courtesy of the Historic Photo Collection, Harpers Ferry National Historical Park.)

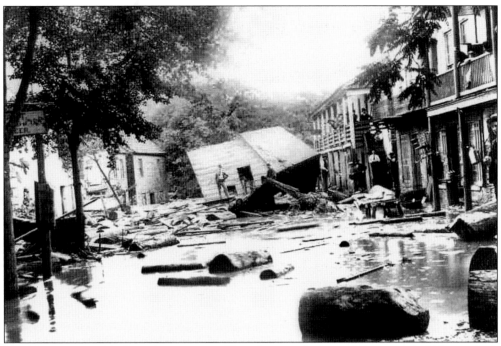

THE FLOOD OF 1889, THE AFTERMATH. This photograph shows the west end of Shenandoah Street in the aftermath of the 1889 flood. This flood was one of the most devastating to ever hit Harpers Ferry. People seem to be standing around in shock, looking in awe at the damage Mother Nature has caused. The remains of an upturned building can be seen farther down the street as well as large logs in the street. (Courtesy of the Historic Photo Collection, Harpers Ferry National Historical Park.)

THE FLOOD OF 1889, CANAL DAMAGE. This photograph shows the damage that the Maryland Heights shore sustained. The damage the Chesapeake and Ohio Canal suffered can also be seen. Lock #33 sustained considerable damage, as did the canal boats. In the background is the "Salty Dog" Tavern. This spot is opposite Harpers Ferry. (Courtesy of the Historic Photo Collection, Harpers Ferry National Historical Park.)

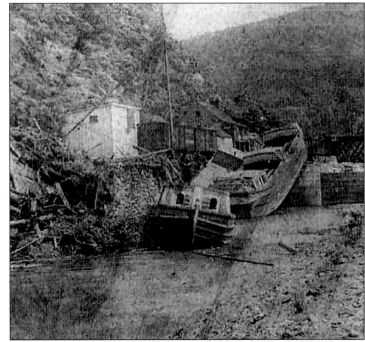

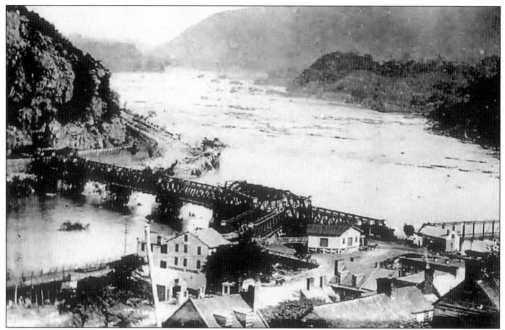

THE FLOOD OF 1889, LOOKING DOWNSTREAM. The Chesapeake and Ohio Canal, just beyond the bridge, was heavily damaged. Fortunately, the Bollman Bridge survived intact. On the far left side of the photograph is Maryland Heights, on the right is Loudoun Heights. To the left is the Potomac River that joins with the Shenandoah just after the Bridge, and then continues on to the Chesapeake Bay and eventually the Atlantic Ocean. (Courtesy of the Historic Photo Collection, Harpers Ferry National Historical Park.)

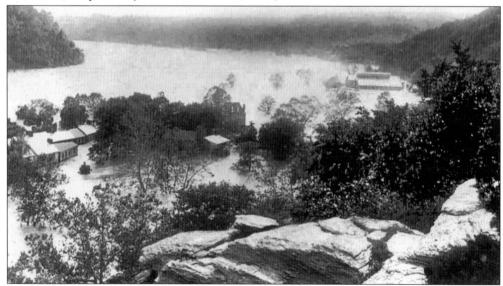

THE FLOOD OF 1889, LOOKING UPSTREAM. In this photograph, Virginius Island is completely inundated with water. In the upper right hand corner, you can see the rooftop of the new Shenandoah Pulp Company. In 1889, when this was taken from atop Jefferson Rock, one house can be seen on the island, along with the old flour mill. (Courtesy of the Historic Photo Collection, Harpers Ferry National Historical Park.)

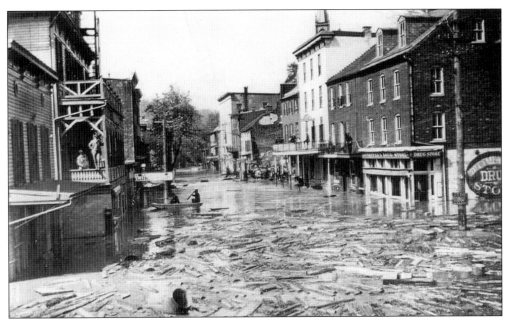

THE FLOOD OF 1924. Flood damage is viewed from the east end of Shenandoah Street. The flood inundated the downtown portion of the town, visible halfway up the buildings. There appears to be a person on a boat or canoe to the left center of the picture. The water had not yet receded when this photograph was taken, so clean up had not yet begun. (Courtesy of the Historic Photo Collection, Harpers Ferry National Historical Park.)

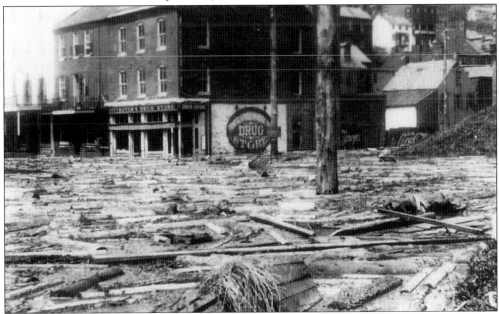

THE FLOOD OF 1924, PULP DEBRIS. This photograph was taken in the Lower Town at the corner of Potomac and Shenandoah Streets. The flood occurred May 14, 1924, and much of what is seen in this photograph was pulpwood debris from the Shenandoah Pulp Mill. The Mill was located above Virginius Island and the debris was washed down from there. (Courtesy of the Historic Photo Collection, Harpers Ferry National Historical Park.)

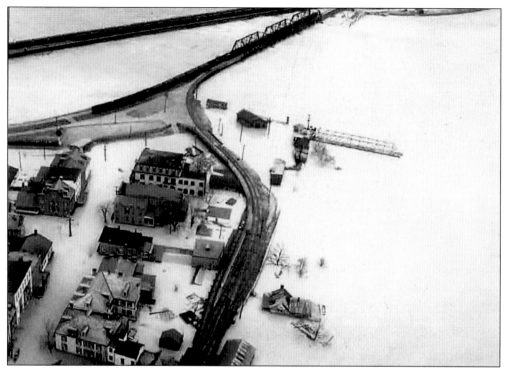

The Flood of 1936, Aerial View. Shortly after this was taken, the bridges across both the Shenandoah and Potomac Rivers were swept away. On the left side are the buildings that house the John Brown Museum today. (Courtesy of the Historic Photo Collection, Harpers Ferry National Historical Park.)

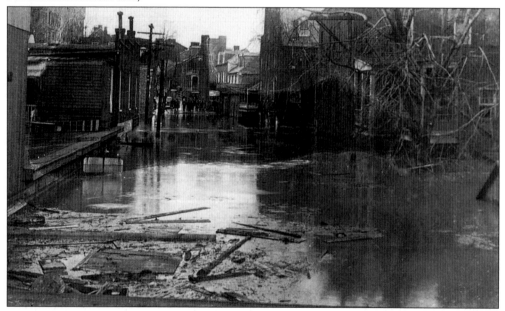

The Flood of 1936, Lower End of High Street. It was taken from the W&P Trestle when the floodwater was at the second story level. This is the southern end of High Street. (Courtesy of the Historic Photo Collection, Harpers Ferry National Historical Park.)

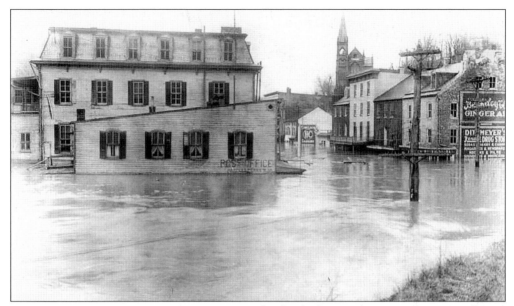

THE FLOOD OF 1936, LOWER TOWN. During the flood of 1936, the rivers rose to an all-time crest of 36.5 feet. During the flood, both the Bollman and the Shenandoah River Bridges were washed away. The Catholic church can be seen in the background, to the right of center. The Post Office building, left center, appears to be flooded up to the second floor. (Courtesy of the Historic Photo Collection, Harpers Ferry National Historical Park.)

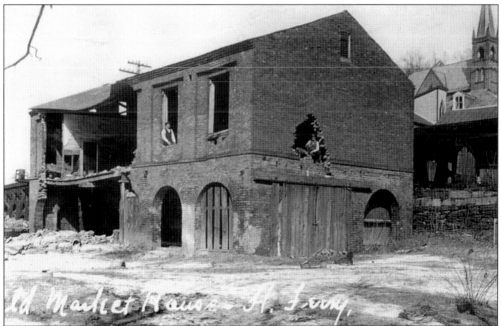

THE FLOOD OF 1936, OLD MARKET HOUSE. The damage caused by the 1936 flood can be seen in this photograph of the "Old Market House." The building was built by the government between 1846 and 1847. For many years fish, eggs, meats, poultry, cheese, and vegetables were sold in this town market every Wednesday and Saturday. (Courtesy of the Historic Photo Collection, Harpers Ferry National Historical Park.)

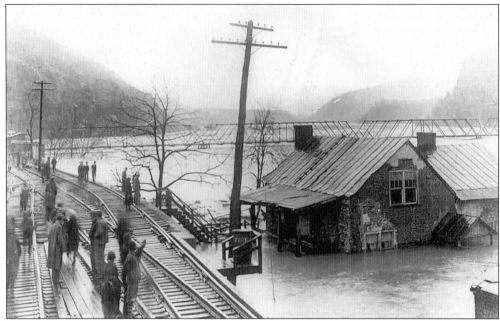

THE FLOOD OF 1936, PAYMASTER'S HOUSE. During the flood of 1936, the water reached record levels. Here the former Armory Paymaster's house is under water. It was located on the banks of the Shenandoah River and was inundated with floodwater. People can be seen walking on the railroad tracks, surveying the flood damage. (Courtesy of the Historic Photo Collection, Harpers Ferry National Historical Park.)

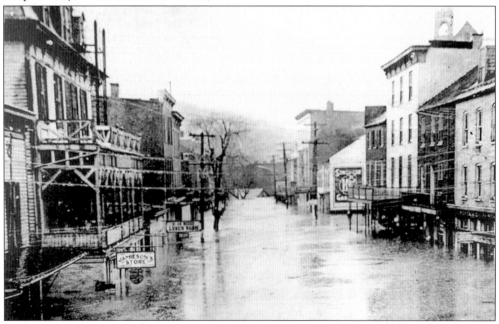

THE FLOOD OF 1936, SHENANDOAH STREET. During the flood of 1936, Shenandoah Street was impassable except by boat. The floodwaters are shown approaching the second stories of the buildings. This was not the last flood that Harpers Ferry would experience. (Courtesy of the Historic Photo Collection, Harpers Ferry National Historical Park.)

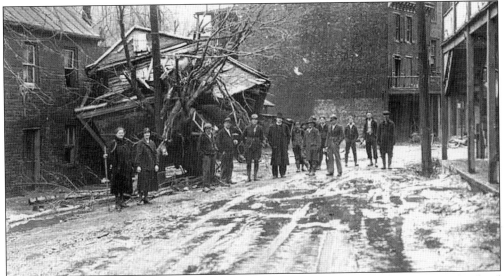

THE FLOOD OF 1936, AFTERMATH. This is a photograph of Shenandoah Street after the flood of 1936 receded. On the right is Park Building 45, which now houses the Park Bookshop. Formerly, it was known as the Stagecoach Inn. All of the buildings on the east side (left in the picture) of the street are now gone. Here, people survey the damage to the Lower Town. (Courtesy of the Historic Photo Collection, Harpers Ferry National Historical Park.)

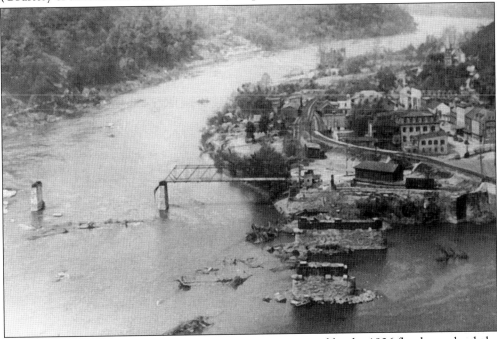

THE FLOOD OF 1936, VIEW OF DAMAGE. The damage caused by the 1936 flood can clearly be seen in this photograph. Both of the highway bridges across the Shenandoah and Potomac Rivers have been washed away. In the distance, the ruins of the old Cotton Factory can be seen on Virginius Island. The cars along Shenandoah Street suggest the cleanup had been done when this photograph was taken. (Courtesy of the Historic Photo Collection, Harpers Ferry National Historical Park.)

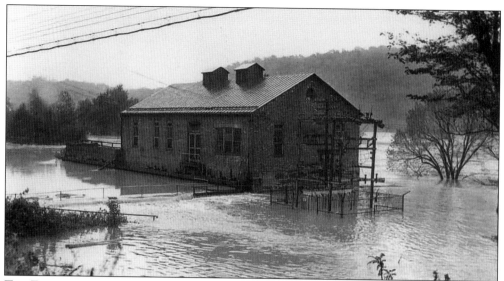

THE FLOOD OF 1942, POWER PLANT. During the flood of 1942, the Potomac Power Plant was inundated. Some sources refer to this building as the Harpers Ferry Power Plant, while others refer to it as the Potomac Power Plant. Whenever a flood came to Harpers Ferry, people's lives were disrupted and 1942 was no exception. (Courtesy of the Historic Photo Collection, Harpers Ferry National Historical Park.)

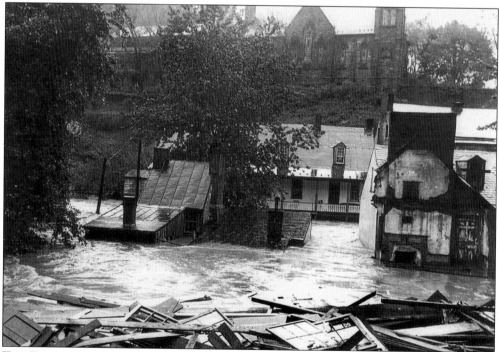

THE FLOOD OF 1942. This photograph shows Shenandoah Street during the flood. The rear portion of various buildings can be seen. This view of the buildings between Market Street and Bridge Street was taken from the W&P trestle. In the distance, St. Peter's Catholic Church can be seen, high on the hill where it was protected from the destructive floodwaters. (Courtesy of the Historic Photo Collection, Harpers Ferry National Historical Park.)

Nine

STORER COLLEGE

After the Civil War was over and the slaves were freed, the freedmen faced the great task of getting on with their lives. However, they were not trained or educated to fend for themselves. To meet their needs, in 1865 Rev. Nathan C. Brackett, of New England's Freewill Baptist home missions, established a primary school in the Lockwood House. There he taught reading, writing, and arithmetic to children of former slaves.

By 1867, there were 2500 students and only 16 teachers and Brackett realized that the only way to reach all the students was to train African-American teachers. The original grammar school evolved into a college.

New England businessman John Storer donated $10,000 to help the school get started with several stipulations. First, the school must eventually become a degree-granting institution. Second, the school had to be open to everyone regardless of race, sex, or religion. Third, and probably the biggest hurdle, the Freewill Baptist Church had to match the $10,000, a feat they accomplished after a yearlong effort. In addition to those hurdles, the residents of Harpers Ferry were vehemently opposed to such a school and used everything from vandalism to pulling political strings to stop the establishment of the school, but to no avail.

Storer College was triumphantly established on October 2, 1867, and in the spring of 1868 it was granted a charter by the state of West Virginia. The U.S. Government deeded several buildings to the college for classes and offices.

For 88 years it flourished, graduating an annual average of 150 men and women. In 1954, the Supreme Court Decision of Brown vs. the Board of Education dealt a blow to the college as the ruling caused West Virginia to withdraw sorely needed contributions. In June of 1955, Storer College closed its doors for good, a sad ending to an illustrious beginning.

Storer College Beliefs. Inside a Storer College building this statement was found, "The Truth Shall Make You Free," adapted from The Bible. Founded with a Baptist affiliation, the college stressed daily chapel attendance, with church and Sunday school attendance required. In addition, Bible study was an essential part of class work. The Storer College ideal was that every student should strive to be a positive religious force. Positive Christian ideals and sound scholarship were admired and sought by all students and faculty. (Courtesy of West Virginia and Regional History Collection, West Virginia University Libraries.)

COMPOSITE POSTCARD. This postcard is a composite of some of the buildings of Storer College. In the upper left is Brackett Hall, upper right is Mosher Hall, lower left is Permelia Eastmen Cook Hall, lower right is the president's home, and in the center is Anthony Memorial Hall. Established in 1867, Storer accepted students with no restrictions on race, sex, or religion. (Courtesy of the Historic Photo Collection, Harpers Ferry National Historical Park.)

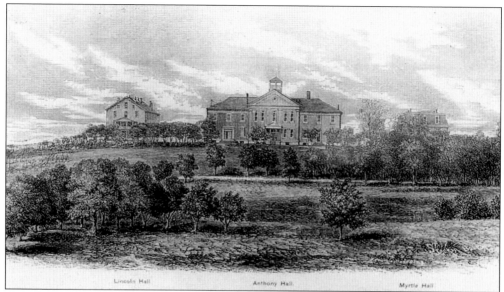

STORER COLLEGE CAMPUS. This sketch appeared on the outside, back cover of an 1889 college catalogue for Storer College. The college was founded in 1867 as a normal school with Baptist affiliation. Founded to educate students with no regard for race, sex, or religion, the above buildings were given to the school by the U.S. Government. From left to right are Lincoln Hall, Anthony Hall, and Myrtle Hall. The school graduated an average of 150 men and women annually and closed in 1955. (Courtesy of the Historic Photo Collection, Harpers Ferry National Historical Park.)

LOCKWOOD HOUSE, 1958. The third floor and the mansard roof had been added by Storer College. When the building became a part of the Harpers Ferry National Historical Park, the third floor was removed to make the building resemble more closely its original structure. (Courtesy of the Historic Photo Collection, Harpers Ferry National Historical Park.)

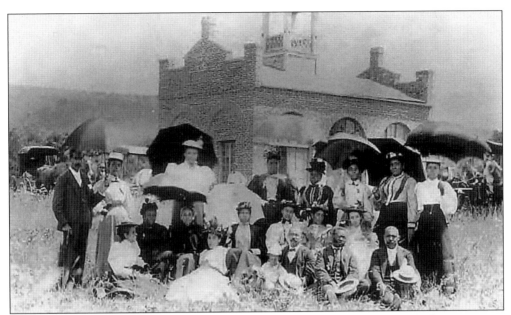

PILGRIM PARTY. Members of a pilgrim party from the National League of Colored Women pose in front of John Brown's Fort. This photograph was taken July 14, 1896. John Brown's Fort was located on the Alexander Murphy Farm from 1895 to 1909. The Murphy Farm was located on a bluff that overlooked the Shenandoah River. The Fort would later be moved to its present location in Lower Town. (Courtesy of the Historic Photo Collection, Harpers Ferry National Historical Park.)

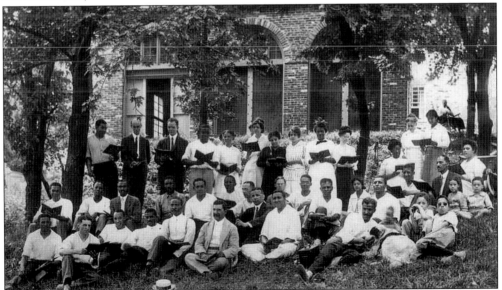

A STORER COLLEGE GROUP. This photograph was taken sometime between 1910 and 1955. Based on their clothing, it appears to be between 1910 and 1935. This group of Storer College Students might be a choir. The group of 47 people is standing and sitting on the campus, in front of the John Brown Fort. Some of the people are holding books, which could possibly be hymnals, although that is not certain. There are also some children seated with the group on the grass. (Courtesy of the Historic Photo Collection, Harpers Ferry National Historical Park.)

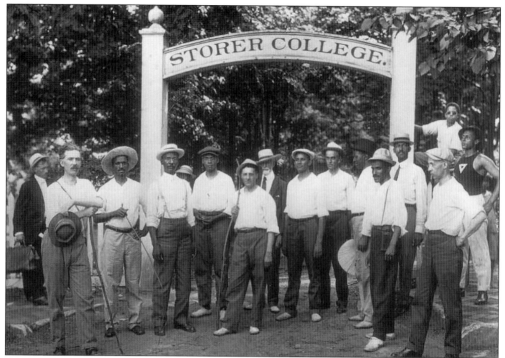

STORER COLLEGE STUDENTS. This photograph shows a group of 15 students standing in front of the entrance gate to Storer College. Prof. Henry T. McDonald is standing on the left, with his hat in his hand. Dr. Madison Brisco (?) is standing in the front on the right, with his hand on his hip. Others are unidentified. The date is also unknown but it was before 1955. (Courtesy of the Historic Photo Collection, Harpers Ferry National Historical Park.)

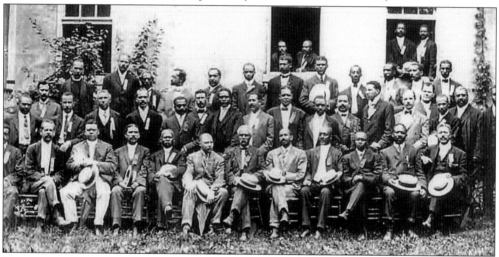

THE NIAGARA CONFERENCE. Pictured here are the delegates to the Second Niagara Conference. This photograph was taken on April 17, 1906, when the Niagara Conference was held on Storer College campus in Harpers Ferry, West Virginia. Taken in front of Anthony Hall, the Niagara Movement was an early civil rights movement. It was a precursor to the National Association for the Advancement of Colored People. (Courtesy of the Historic Photo Collection, Harpers Ferry National Historical Park.)

Ten

HARPERS FERRY TODAY

Today, Harpers Ferry is alive and well. Having been designated a National Historical Park has guaranteed that the town will have a future. Its history will be preserved and not forgotten.

Today, a visit to Harpers Ferry is enlightening and soothing as you take a step back in time, wander the old streets, and imagine all that went on here. However, one visit will not suffice if you really want to learn everything about this little town and what it has given to our country.

Your visit should start at the Cavalier Heights Visitor Center, where rangers will direct you in the programs offered for the day. They will also inform you of any upcoming events or reenactments. They have a small selection of books and materials for sale.

After you take the coach into town, visit the exhibits at your leisure. Then be sure and stop at the bookstore where there is a large collection of historical items, from books to puzzles, something for everyone.

If you have time, visit the numerous shops and restaurants in the little town, or bring a lunch and enjoy a picnic on the banks of the Shenandoah River. Enjoy the lovely setting at the convergence of the two rivers, watch the trains travel on the overhead bridge, listen to the buildings as they tell you their story, or just close your eyes and imagine what it was like when Harpers Ferry was at the forefront of our nation's history.

Harpers Ferry is a place that you can visit repeatedly and learn something new each time, as the National Park Service keeps expanding their exhibits to add more information.

CAVALIER HEIGHTS VISITOR CENTER. After you enter the park, a visitor's first stop in Harpers Ferry is at the Cavalier Heights Visitor Center, so named for the former owners of the land on which it sits. Rangers are available to dispense brochures and information on park sites and activities. Just outside the center is a covered area where visitors wait to catch the shuttle buses that transport them into the Lower Town. As you travel on the bus listen to the story of Harpers Ferry played on the bus intercom system, and be prepared to go back in time to experience the history of Harpers Ferry at the time of John Brown's Raid, in 1859. In addition, after you have finished visiting the town, take time to have a picnic in the picnic area that is adjacent to the large parking lot. (Photo by Dolly Nasby.)

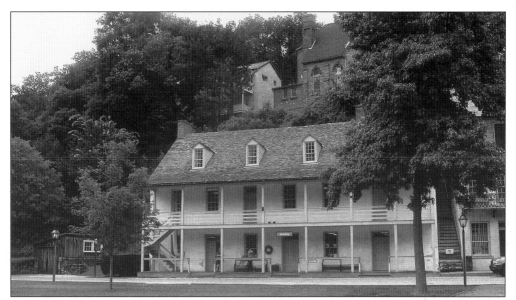

THE BOOK STORE. Housed on the main floor of the John G. Wilson Building is the bookstore. A stop here is necessary because many publications are carried that deal specifically with Harpers Ferry. They often carry items that cannot be found elsewhere. It is definitely a valuable stop when you visit Harpers Ferry. (Photo by Dolly Nasby.)

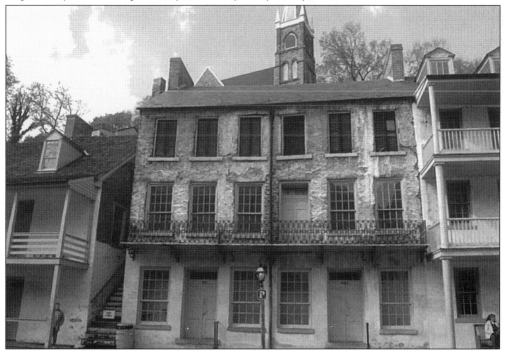

THE MASONIC HALL. Today, the Park Service provides modern restrooms for visitors on the main floor of the old Masonic Hall. The main floor had to have many alterations in order to install the restrooms in the 1960s. They are open year round, as is the entire park. The men's room is on the left and the women's is on the right. As you face the building, the bookstore is to the left of the Masonic Hall. (Photo by Dolly Nasby.)

THE FLOOD LEVELS. On this wall, the various levels of floods have been recorded for comparison purposes. As you read the story of the various floods on the plaques below the gauge, imagine what it was like to experience the floods. The floods on the gauge from top to bottom read: 1936, 1889, 1942, 1896, 1972, 1985, 1996, 1996, 1924, and 1902. (Photo by Dolly Nasby.)

LOOKING DOWN HIGH STREET. Today, the roads are paved and well traveled. Residents have special permits for their vehicles because there is very little parking in the Lower Town. Visitors are encouraged to park at the Cavalier Heights Visitor Center and take the free shuttle buses into the Lower Town. Public Way is the road that angles to the right, leading walkers up to St. Peter's Catholic Church and further up the hill to Jefferson Rock. (Photo by Dolly Nasby.)

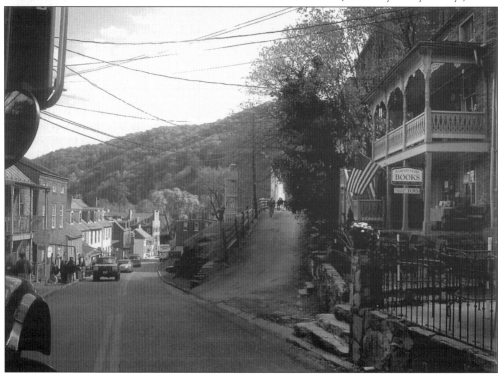

JOHN BROWN'S FORT. John Brown's Fort, located in the Lower Town along Shenandoah Street, is easily the most recognized building in Harpers Ferry. Here are tourists Ray and Linda Weaver (on left) from Indiana, Pennsylvania, and Walt Wojcik (on right), from Harpers Ferry, West Virginia. These tourists, even though they've been here before, keep coming back because, as Walt says, "I learn something new every time I come." (Photo by Dolly Nasby.)

THE APPALACHIAN TRAIL CONFERENCE. Located in the Upper Town on the corner of Washington Street and Jackson Street sits the Appalachian Trail Conference. From November through April, the hours are Monday through Friday from 9 a.m. until 5 p.m. During the summer, from May through October, the hours are Monday through Friday, 9 a.m. until 5 p.m. as well as Saturdays, Sundays, and holidays from 9 a.m. until 4 p.m. Between three and four million people from all over the world hike some part of the Trail each year. In addition, over 375 people walk the entire length in one continuous journey; thereby becoming what is known as "thru-hikers." The office dispenses information readily for hikers about the amenities of the local communities. (Photo by Dolly Nasby.)

THE TRAINS TODAY. Trains still come through Harpers Ferry today, but not nearly as many as in the past. The Marc train takes commuters to and from Washington, D.C., daily. Freight trains come and go during the day and at night. In addition, at night, in the quiet neighborhoods around Harpers Ferry, you can hear the train whistle blow, reminding its residents of a glorious past and a promising future. (Photo by Dolly Nasby.)

A New Beginning. A new day will dawn for Harpers Ferry as it continues to flourish in new and unforeseen ways. St. Peter's Catholic Church, high up on the hill in Harpers Ferry, was the only church that was able to continue to have regular services even during the Civil War. It thrives today with a group of local members of a Charles Town church who serve as docents in period costumes to lead and lecture tour groups, teaching them the traditions of Harpers Ferry. (Photo by Dolly Nasby.)

BIBLIOGRAPHY

Barry, Joseph. *The Strange Story of Harper's Ferry*. Shepherdstown, WV: The Shepherdstown Register, Inc., 1994.

Brown, Stuart E. *The Guns of Harpers Ferry*. Baltimore, MD: Genealogical Publishing Co., Inc., 2002.

Dilts, James D. *The Great Road*. Stanford, CA: Stanford University Press, 1993.

DuBois, W.E.B. *Biography of a Race*. New York: Henry Holt and Company, 1993.

Hearn, Chester G. *Six Years of Hell*. Baton Rouge: Lousiana State University Press, 1996.

http://www.johnbrown.org/provisionarlarmy.htm

Oates, Stephen B. *To Purge This Land With Blood*. Amherst: The University of Massachusetts Press, 1984.

Potter, Stephen R. *Commoners, Tribute and Chiefs*. Charlottesville: University Press of Virginia, 1994.

Quarles, Benjamin. *Allies for Freedom & Blacks on John Brown*. England: Oxford University Press, 1974.

Shaw, Ronald E. *Canals for A Nation*. Lexington: The University Press of Kentucky, 1990.

Smith, Merritt Roe. *Harpers Ferry Armory and the New Technology*. Ithaca: Cornell University Press, 1977.

Summers, Festus P. *The Baltimore and Ohio in the Civil War*. Gettysburg: Stan Clark Military Books, 1993.

U. S. Department of the Interior. *John Brown's Raid*. Washington, D.C.: Office of Publications, National Park Service, 1974.